PAINTING CHILDREN

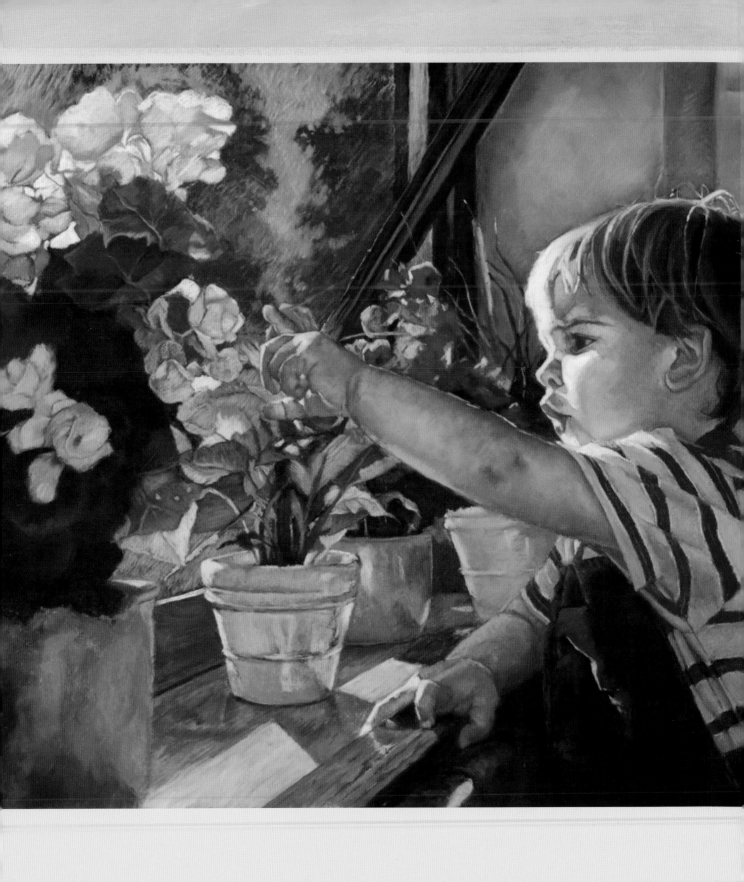

PAINTING
Children

secrets to capturing
childhood moments

Bev Lee

NORTH LIGHT BOOKS
CINCINNATI, OHIO
www.artistsnetwork.com

ABOUT THE AUTHOR

For as long as she can remember, art has been a large part of Bev Lee's life. Pencil and paper have always been like candy to her. Bev is particularly intrigued by the way light falls on living things. She expresses this best in her fresh paintings of children. Although the decision to home-school her own children put her career on hold for several years, Bev began devoting more time to art ten years ago, when her kids became more self-directed in their studies. She believes one must be totally committed to something for it to work well. Since then, Bev's work has earned over fifty awards, including many best-of-show and people's choice awards. Bev was featured in an article in *The Pastel Journal*, and her work has appeared in *The Artist's Magazine*, *The International Pastel Artist* and *International Artist*.

Bev has taken workshops with Doug Dawson, Terry Ludwig, Xiang Zhang and Daniel Greene. She has also attended classes at Mesa State College in Grand Junction, Colorado. She feels she has gained many wonderful insights by studying with great artists but acknowledges that she has learned the most from studying art books and through hours of painting experience.

Bev is a signature member of the Pastel Society of America and the Pastel Society of Colorado, of which she is vice president. She currently lives with her husband in western Colorado, where she paints full time and teaches both private and group classes.

Art on page 2

BOTANY LESSON
Pastel on Wallis Sanded Pastel Paper
18" × 24" (46cm × 61cm)

Painting Children: Secrets to Capturing Childhood Moments. Copyright © 2008 by Bev Lee. Manufactured in China. All rights reserved. No part of this book may be reproduced in any form or by any electronic or mechanical means including information storage and retrieval systems without permission in writing from the publisher, except by a reviewer who may quote brief passages in a review. Published by North Light Books, an imprint of F+W Publications, Inc., 4700 East Galbraith Road, Cincinnati, Ohio, 45236. (800) 289-0963. First Edition.

Other fine North Light Books are available from your local bookstore, art supply store or visit our website at www.fwpublications.com.

12 11 10 09 08 5 4 3 2 1

DISTRIBUTED IN CANADA BY FRASER DIRECT
100 Armstrong Avenue
Georgetown, ON, Canada L7G 5S4
Tel: (905) 877-4411

DISTRIBUTED IN THE U.K. AND EUROPE BY DAVID & CHARLES
Brunel House, Newton Abbot, Devon, TQ12 4PU, England
Tel: (+44) 1626 323200, Fax: (+44) 1626 323319
Email: postmaster@davidandcharles.co.uk

DISTRIBUTED IN AUSTRALIA BY CAPRICORN LINK
P.O. Box 704, S. Windsor NSW, 2756 Australia
Tel: (02) 4577-3555

Library of Congress Cataloging in Publication Data
Lee, Bev
 Painting children : secrets to capturing childhood moments / by Bev Lee.
-- 1st ed.
 p. cm.
 Includes index.
 ISBN 978-1-60061-038-7 (hardcover : alk. paper)
1. Pastel drawing--Technique. 2. Portrait drawing--Technique. 3. Children in art. I. Title.
 NC880.L43 2008
 704.9'425--dc22 2008022962

Edited by Mary Burzlaff
Designed by Wendy Dunning
Production coordinated by Matt Wagner

Metric Conversion Chart

To convert	to	multiply by
Inches	Centimeters	2.54
Centimeters	Inches	0.4
Feet	Centimeters	30.5
Centimeters	Feet	0.03
Yards	Meters	0.9
Meters	Yards	1.1

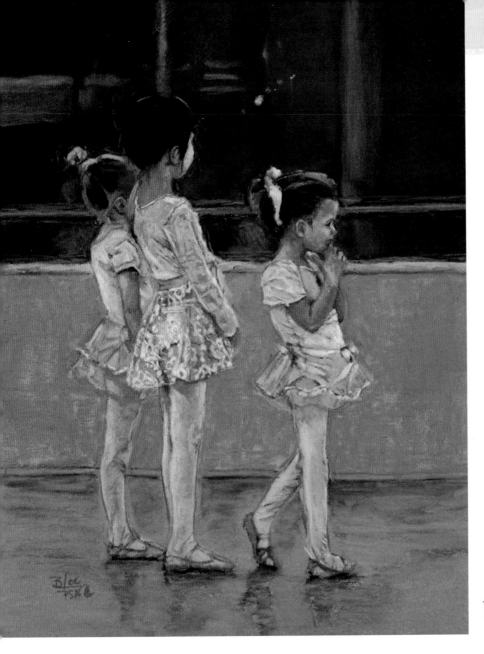

WAITING, FIRST RECITAL
Pastel on Ampersand Pastelbord
14" × 11" (36cm × 28cm)

ACKNOWLEDGMENTS

To God, the creator of all things. Thank you for good gifts.

To Nancee Jean McClure, a wonderful artist, illustrator and friend. Thank you for encouraging me and helping me to propose this book. Your advice and help, especially with computer and camera issues, have been invaluable.

To Jamie Markle, who kept the idea of a portrait book in pastels alive and presented it to the board of F+W Publications, Inc.

To Mary Burzlaff, my editor, who has been patient throughout all the work and questions.

Thanks to all of the models who appear in this book. Children are so wonderful and these were truly fun to work with.

A very special thanks to Justin, Bethany, Cody, Isabella, Dulcey Anne, Elliana, Anna-Claire, and Elisabeth, who were always there for me, available at the drop of a hat anytime I had a new idea or needed a hand to repaint.

DEDICATION

I dedicate this book to my husband Charlie. You have supported and helped me to realize my dream of becoming an artist. You have never lost faith in my abilities and have put up with a lot of pastel dust and late dinners.

Table of Contents

INTRODUCTION 8

CHAPTER 1
The Right Materials 10
Surfaces · Toning the Surface · Pastels · Using Pastels · Miscellaneous Supplies

CHAPTER 2
Choosing Subjects and Reference Materials 20
Composing the Scene · Poor-Quality Reference Photos · Good-Quality Reference Photos · Capturing Hands in Reference Photos · Combining Reference Photos

CHAPTER 3
Mapping 28
General Dimensions and Proportions · Demonstration: Mapping

CHAPTER 4
Color 36
Make a Color Wheel · Color Schemes · Mixing Colors With Pastels · Temperature · Skin Tone Color Charts

CHAPTER 5
Painting *the* Face 46
The Eye · The Mouth · The Teeth · The Nose · The Ear · Curly Hair · Straight or Wavy Hair · Demonstration: Dark Skin Tones, Three-Quarters View · Demonstration: Medium Skin Tones, Front View · Demonstration: Light Skin Tones, Angled Front View

CHAPTER 6
Painting *the* Hands 72
Focusing on Hands · Keeping the Hands in Proportion · Sketching Hands · Demonstration: Grasping Hands · Demonstration: Baby Hands · Demonstration: Cupped Hand · Demonstration: Graceful Hands

CHAPTER 7
Fabric *and* Clothing 90
Demonstration: Tulle · Demonstration: Satin · Demonstration: Fur · Demonstration: Knit Hat · Demonstration: Plaid · Demonstration: Checks · Demonstration: Denim

CHAPTER 8
Putting It All Together 106
Demonstration: Seated Figure · Demonstration: Figure With Varied Fabrics · Demonstration: Figures With Curly Hair

CONCLUSION 126

INDEX 127

FOUNTAIN OF YOUTH
Pastel on La Carte Pastel Card
24" × 18" (61cm × 46cm)

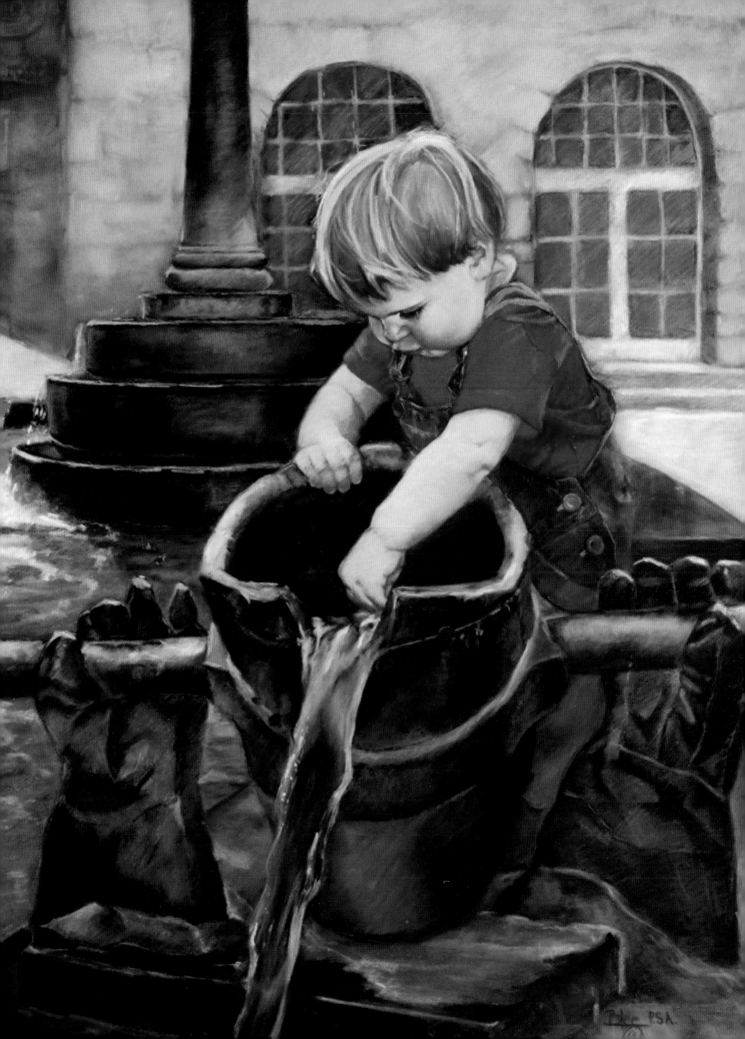

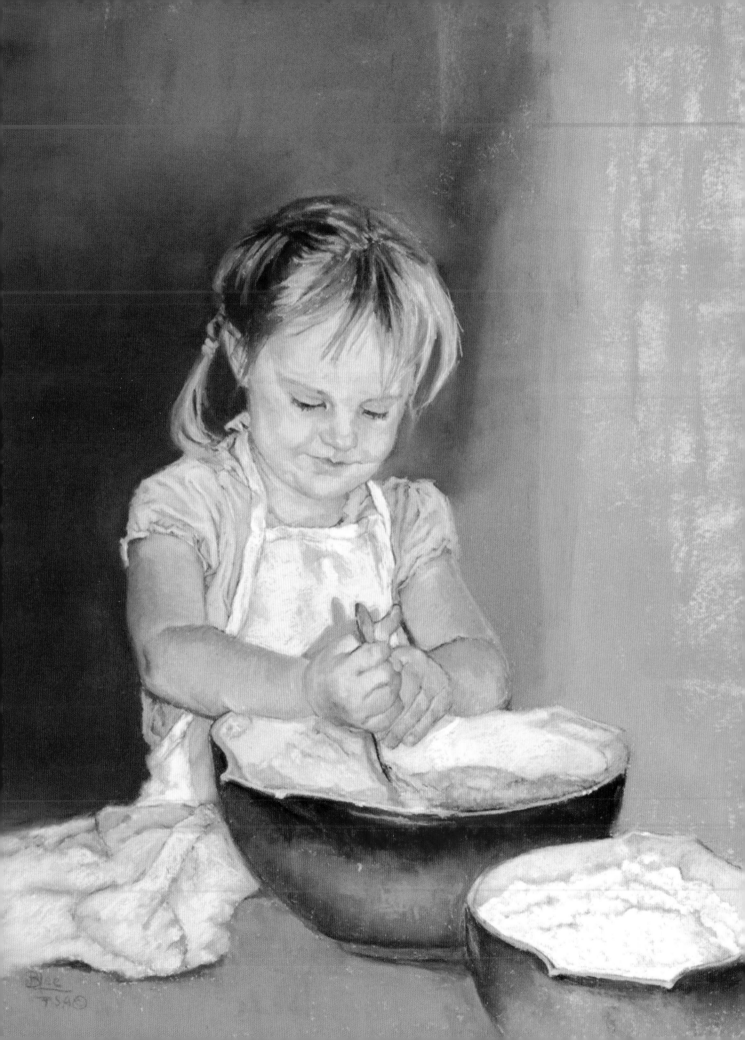

Introduction

I find great inspiration and satisfaction in painting portraits, especially portraits of children. Children make me smile. I want to pass this smile on to others as they view my work.

Over the years, I have developed a process that works well for both me and my students. This process allows you to determine whether or not you have achieved a likeness before you spend a lot of time on the project. It is easier to make corrections in the early stages than after you have painted layers of pastel. Instead of drawing the face in detail and filling it in, mark positions. Then, working from the inside out, paint shapes and values. Some refer to this method as "puzzle painting," because you focus on what shape, value and color will fit with what you've already painted. This method works for any subject. It is my hope that it will free you from fear as you begin to see the face as a collection of shapes, values and colors.

Pastel lends itself so well to portrait painting. It is fresh and forgiving. It is also a direct medium, which means that whatever you put down will look the same whenever you come back to it. There is no darkening or dulling of color. No matter if your style is realistic, abstract or impressionistic, whether you use broad strokes or small linear strokes, pastel is a great medium. You can apply a thin layer or several rich ones. When my plate is very full, it's nice to know that even if I have only thirty minutes, I can run in and get somewhere with a painting without a lot of setup or cleanup.

Wherever you are on your path as an artist, I believe this book offers a practical guide to success with your own portraits. It offers a nuts-and-bolts approach, starting with each individual feature and moving on to a completed composition.

Painting is a lifelong adventure full of ups and downs. Our "ah ha!" moments come at times in thimblefuls, at others, in bucketfuls. I hope this book will be a jumping-off place where you can begin to develop the process that works best for you.

COOKIE DOUGH
Pastel on Wallis Sanded Pastel Paper
20" × 17" (51cm × 43cm)

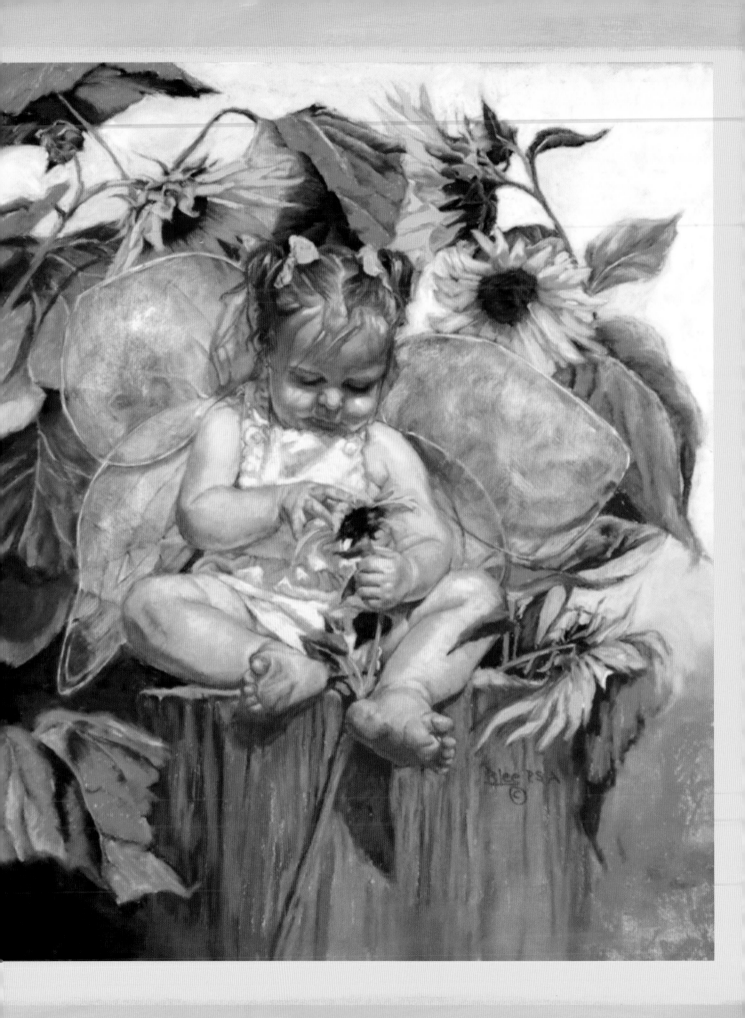

1 *the* Right Materials

You've probably seen the cartoon with the artist at the art store looking at the paint brushes. She knows that if she could only find the right brush, she could paint a masterpiece. While owning a grand piano will never make me a pianist (I can't play a note), if I could play, the piano would make me sound better. The right materials can make an artist an even better artist. They can also eliminate a great deal of frustration.

Getting the right materials for the job is very important. For years I struggled along with a limited set of pastels and drawing paper. At a meeting of the Pastel Society of Colorado several years ago, someone mentioned different papers. Who knew that there was more than one kind of paper out there? So I began hunting for the paper or surface that best suited what I wanted to convey. At about the same time, I started trying different brands of pastels. My work transformed almost immediately.

This chapter offers a brief description of the best materials I have found through years of experimenting. I hope it will aid you in your choices.

SUNFLOWER PIXIE
Pastel on Wallis Sanded Pastel Paper
18" × 15" (46cm × 38cm)

Surfaces

Papers, boards, grounds: The terms relating to surfaces used in pastel painting can be confusing. These surfaces range from thin papers to heavy boards prepared with gritty substances called grounds. The latter can be purchased from different manufacturers, or you can prepare them yourself.

Although I purchase most of my surfaces ready to go, I have experimented with making my own. You can do this by painting a gritty substance—generally made with fine marble dust or fine pumice mixed with a gesso medium—onto a heavy paper or board. Untempered Masonite is a good surface to use. It is helpful to slightly sand the surface first. A basic recipe is one part grit to two parts gesso medium. This mixture may be toned using acrylic paint. Use a large house-painting brush to apply the ground to your surface. Paint at least two layers, stroking one direction for the first and the opposite direction for the second.

The tooth of a paper refers to its texture and ability to hold onto the pastel. One definition describes tooth as the surface feel of the paper. If a paper has less tooth or is slick, pastel will not adhere or not adhere well. Conversely, if a paper has a lot of tooth, it will hold on to the pastel. The more tooth a paper has, in theory, the more layers of pastel it will take. I prefer paper with a lot of tooth as long as it is fine and evenly applied. If a paper has too much tooth or is too rough or uneven, it's harder to render the detail I enjoy.

I love the challenge of trying new papers, pastels and grounds, but it takes work. Each time you change to a new surface, you have to learn what it will and will not take: how many layers, how much texture, etc. Also, each new surface color presents new challenges. The color of your pastel will react differently depending on the color of the surface. So, the yellow you laid down on the blue surface will look different from the same yellow applied on a brown one.

To gain consistency in style, I have narrowed my materials to only a few types of surfaces. When I tone a surface, I generally use the same colors. There are fewer surprises that way. Even though it is fun to experiment—and I heartily recommend it—experimentation can be frustrating because it requires constant relearning. So, for a while anyway, I suggest using the same color and type of surface until you feel confident enough to move on.

On pages 13–15, there are six paintings created on six different surfaces. You can see that the texture and color have a great effect on the style and look of the painting. Beside each painting, I have listed the pros and cons of working with that particular surface.

COMMON PASTEL SURFACES

These are the surfaces most commonly used by pastel artists. Experimenting will help to narrow them down to the one or two that will become your favorite—the ones that give you the effect you are after. Note: The Ersta pictured here is not currently available, but UART sanded pastel paper (see page 13) is very similar to Ersta.

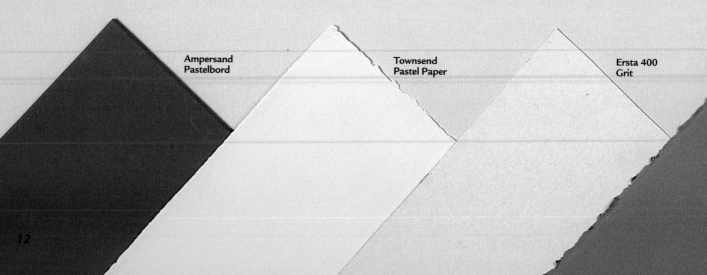

Ampersand Pastelbord

Townsend Pastel Paper

Ersta 400 Grit

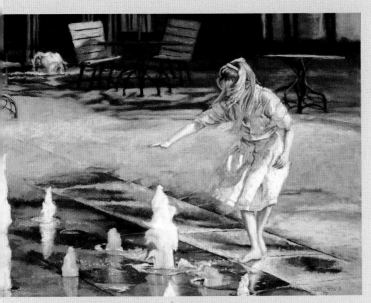

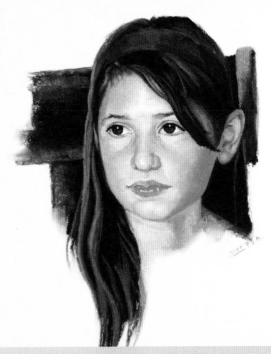

AMPERSAND PASTELBORD

PROS

Ampersand Pastelbord has a very nice, even texture. The stiff board can be easily transported without any other support. Ampersand comes in four colors, including white, which can be toned (see page 16). Many layers of pastel may be used, which allows for a vast range of artistic styles from loose and textural to very detailed and realistic. I prefer the green for my portraits, so I can skip the toning stage. This surface is museum quality and pH neutral.

CONS

This is a wonderful surface for painting on, but it's at the higher end of the price scale. Although the board support can be a benefit, it can also be a problem. Sometimes I find that a painting is just not working and decide that cropping would improve the composition. However, this board is not suited for cropping. While an electric saw may work for cropping an oil or acrylic painting, it would make pastel dance all over!

DANCING WATERS II
Pastel on Ampersand Pastelbord
18" × 24" (46cm × 61cm)

UART SANDED PASTEL PAPER

PROS

UART was developed to replace the German paper Ersta, which had been one of my favorite surfaces until it was discontinued. It has the same grit as Ersta, but it is on an archival pH neutral paper. This is a valuable step up since Ersta wasn't archival. UART is available in four grits, ranging from coarse to fine. For this painting of Cherith, I chose coarse 400 grit paper. UART comes in pale, warm Naples yellow and is about the same price as Wallis paper. This surface is very similar to Ersta, and I enjoyed painting on it. I was able to apply many layers and get as detailed as I wanted.

CONS

This surface tends to eat up pastels quickly. Also, as you paint on this surface, the pastel tends to drift downward. This can be a problem if you want to paint a vignette like this painting of Cherith. Tipping your surface forward a bit as you paint can help alleviate this problem. Overall, I really like this paper and will add it to my favorites.

CHERITH AT 10
Pastel on UART Sanded Pastel Paper
17" × 13" (43cm × 33cm)

Saint-Armand Sabretooth
Pastel Paper

Wallis Sanded
Pastel Paper

Art Spectrum Colourfix
Supertooth Board

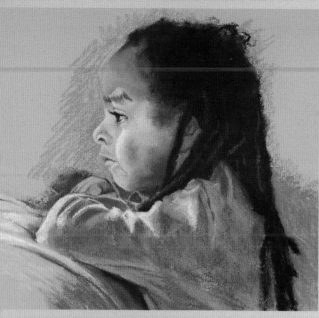

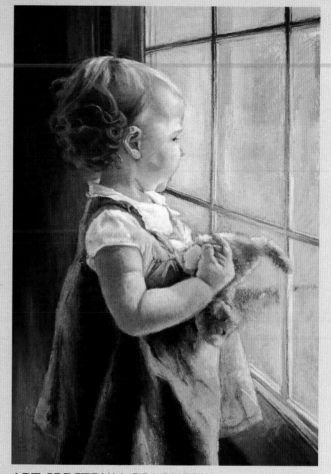

SAINT-ARMAND SABRETOOTH PASTEL PAPER

PROS

Saint-Armand's Sabretooth is a new surface for me. It is archival quality and comes in several colors. I chose olive for this painting. It would be a good paper for artists who want a lot of texture for more impressionistic results in their finished paintings. It is in the middle to lower price range.

CONS

I found the texture a bit uneven for my work. I struggled to get detail. It did work well for portraying Mawusi's black dreadlocks. I found I had to do a lot more blending in the initial stages to cover the tooth. Softer pastels worked better than the harder ones with this paper. I found Ludwig pastels to work the best with this surface.

MAWUSI
Pastel on Sabretooth Pastel Paper
9" × 16" (23cm × 41cm)

ART SPECTRUM COLOURFIX SUPERTOOTH BOARD

PROS

Art Spectrum makes a colored surface called Colourfix, which is available on paper or board. It is available in several colors and is acid-free. For this painting, I used Colourfix Supertooth Board. It has much more tooth and comes only in white. It is also acid-free and can take a wash.

Supertooth is a fun surface to use; it practically paints itself. The texture produces some nice effects. For someone with a heavier touch or who isn't interested in much detail, this paper works well.

CONS

This surface's texture does not lend itself to fine detail. If you want a high level of realism and detail, you might find this surface a bit frustrating. It is in the higher price range.

LOOKING OUT
Pastel on Colourfix Supertooth Board
18½" × 13" (47cm × 33cm)

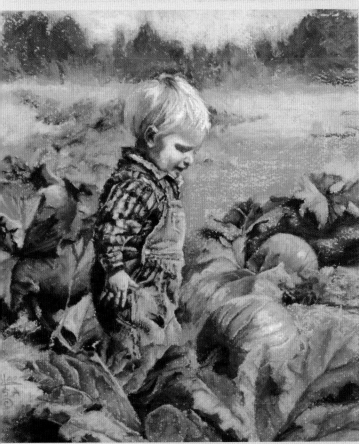

TOWNSEND PASTEL PAPER

PROS

Townsend Pastel Paper is another surface that is new to me, and it quite surprised me. I was a bit nervous about applying a wash because it seemed too thin, but it handled a light wash well. Go easy on the moisture content of the wash. Although the finished painting appears textural, I was able to get quite a bit of detail for such a small study. The Townsend surface is applied to Rives BFK paper, which is 100 percent cotton, archival quality and available in white, cream, gray and tan.

CONS

This surface is in the higher price range. And, again, for painters who like more control and a greater degree of realism and detail, this might not be for you.

THE PUMPKIN
Pastel on Townsend Pastel Paper
11" × 9" (28cm × 23cm)

WALLIS SANDED PASTEL PAPER

PROS

Wallis Sanded Pastel Paper is the surface that I have painted on for the longest period. It comes in sheets of several sizes as well as in rolls. It is available in white or Belgian Mist. There are two grades, a professional grade on pH neutral cardstock and a museum grade on 100-percent-cotton rag. The surface treatment for both is pH neutral. I used to prefer the museum grade, but recently the texture has been changed somewhat. Now I find better success with the professional grade. This is nice as it is less expensive. This surface can take a wash. I have had some problem with water-based washes causing buckling, so use quick-drying mineral spirits. Wallis is a wonderfully versatile surface and can be used for any style an artist wishes. This is an especially good choice for artists who want a great degree of detail in their paintings.

CONS

The texture change has been a bit difficult to adapt to. The tooth seems a bit more uneven in the museum grade. Wallis does tend to eat up the pastels and can be hard on the fingers. However, I love it, and it will continue to be my preference. It is in the middle to higher price range.

THE RED HAT
Pastel on Wallis Sanded Pastel Paper
14" × 11" (36cm × 28cm)

Toning the Surface

Surfaces can be purchased in a variety of colors as well as white. Some artists choose to paint directly onto a white surface. I prefer to paint on a toned surface to create unity in the color scheme, because specks of the tone underneath will show through in the finished painting. There are many ways to tone a surface. I use pastel with odorless mineral spirits or mineral turpentine. I find that water-based washes using watercolor or acrylic can cause buckling. I have had the sad experience of working on an acrylic-toned surface for a commission, only to have some of the pastel repelled by the acrylic. I also have had bad results using organic or natural turpentine or Turpenoid.

1. LAY ON COLOR

Use a hard pastel such as a Prismacolor NuPastel in olive green. Using the side of the pastel, lay down a layer of color. If you do not have an olive green, you may layer another green over an orange or brown to create your own olive color. Keep the strokes light. You don't want too much pigment on the surface at this point or it will fill the tooth.

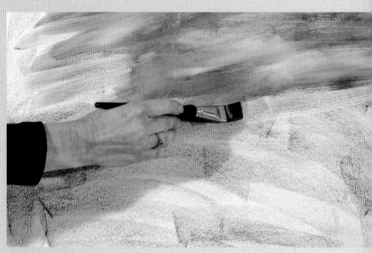

2. BRUSH ON MINERAL TURPENTINE OR MINERAL SPIRITS

Use a large, soft, no. 1 or larger flat bristle brush. Very quickly brush on odorless turpentine or mineral spirits. Make sweeping strokes across the surface. Do not let any sit or puddle to avoid buckling. Remember this is the undertone, so it does not need to be perfect.

3. CREATE BACKGROUND EFFECTS

There are times an artist will choose to leave the background free of pastel. If you're going to leave a lot of the surface untouched, you may want to make some special effects in the toning process. You can do this by quickly dabbing rags or paper towels onto the ground after you have applied the turpentine. You can also splatter turpentine onto the toned surface with an old hard bristle toothbrush.

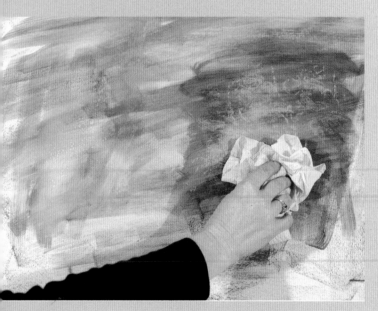

Create a Soft Surface

I clip my surface onto a piece of Masonite board lined with three layers of newsprint. This makes a softer surface to work on. I get free newsprint from my local newspaper office, which gives away unusable end rolls. These rolls can also be cut and stapled into sketch pads.

Pastels

There are many different brands of pastels that range from hard to soft. Harder pastels have more binder and less pigment. Softer pastels have less binder and more pigment and are, therefore, more expensive. The following are the pastels that I use the most, organized from the hardest to the softest:

Prismacolor NuPastel Color Sticks are the hardest pastels that I use. They are very reasonably priced and come in an excellent range of colors. I use NuPastel for marking and early stages of lay-in, but they can be used to create the entire painting. Because they are hard, they don't fill up the tooth of the paper as quickly as other pastels. Other layers may then be applied over them. I usually paint my under-values with them, though they can also be used to blend. NuPastel are also good for glazing if you want to tone down an area.

Rembrandt Pastels are wonderful. They are slightly softer than NuPastel, so they fill the tooth more quickly. These can be used through all stages of the painting process. I use a lot of these in my portrait work. Rembrandt pastels cost more than twice as much as NuPastel and can be purchased in sets or individually. Useful colors include the raw umbers, burnt umbers, raw siennas and yellow ochres.

Townsend Pastels are next on the softness scale and take a jump up in price. They are large and have a unique shape that makes them ideal for laying in large areas of color. The light colors are great for lightest lights.

Unison Handmade Pastels are incredible, but a bit higher in price. They are just right in consistency: not too hard or too soft. They are fat and round but have flat tops and bottoms that enable you to get a nice line when needed. They can be used for laying in large areas or for the tiniest detail. Unison pastels can also be used to blend.

Terry Ludwig Pastels are square in shape, so they produce nice, broad strokes. They are soft, but at the same time have substance. The variety of colors in this brand seems endless. I especially like the darks. The dark red-violet is a must. I use these in large areas such as backgrounds. The

PASTEL SAMPLING

Here is a small selection from my pastel collection.
1. NuPastel
2. Schmincke
3. Terry Ludwig
4. Unison
5. Sennelier
6. Rembrandt
7. Townsend

lighter colors are wonderful for that last stroke of highlight. They can be used for the whole process, but don't work as well for blending. The price is moderate to high, but worth every penny.

I have a memorable story about Mr. Ludwig. Years ago, I went out to paint and absentmindedly put my pastel boxes on top of my car while I unlocked and loaded everything else, then forgot about them. You can guess how pretty the road became that day. When I realized what I had done, I retraced my route and could only sit and watch as drivers crushed all of those wonderful sticks underneath their tires. Terry heard of this mishap and I received two boxes of pastels in the mail.

Schmincke Pastels are very soft. I use them sparingly in the later stages of my paintings. My favorites are the reds. Good reds are hard to find in pastels because they tend to be hard, but these are buttery. They are slightly more expensive than the Rembrandt brand.

Sennelier Pastels are also very soft and tend to break easily, but they make a nice, painterly stroke. I reserve them for the last little touches. I think they would be used up too quickly if used for vast areas. Sennelier makes a wonderful dark green that you shouldn't be without. My selection also includes Sennelier's very lightest colors for highlights. They are about the same price as the Schmincke brand.

Pastel Pencil Warning

I use pastel pencils only to sign my name. I find they can cause artists to become too close and detailed in their work. To keep your work fresh and lively, it is better to work edges together to get a nice line.

Using Pastels

It is better to paint using hard pastels first, then turn to the softer ones. By working this way, you can make corrections more easily in the early stages. It is harder to remove pastel that has already filled in much tooth without damaging the surface. It also generally works better to paint from dark to light. If you paint a dark color over a light color, you are more likely to come up with mud or a chalky appearance. Placing light colors over dark colors helps to keep the painting looking fresh.

WORKING DARK TO LIGHT

Lay down the darkest value in an area first. Next, add a midvalue, overlapping the previous stroke. Finally, blend in the lightest value by overlapping part of the midvalue.

MUTING WITH COMPLEMENTS

Use a stick of a complementary color (see page 40) to lightly graze across a section that seems too harsh or garish.

EXERCISE: MAKE A BOX TO ORGANIZE YOUR PASTELS

You'll need: sheet of foamcore board, 1-inch (25mm) masking tape, craft knife, straightedge and batting material.

1 Cut:
 bottom (1): 13¾" × 9¾" (35cm × 25cm)
 long sides (2): 13¾" × 1¼" (35cm × 3cm)
 short sides (2): 10" × 1¼" (25cm × 3cm)
 top (1): 14¼" × 10¼" (36cm × 26cm)
 dividers (as many as needed): 13¾" × 1" (35cm × 3cm)
2 Tape the short sides to the bottom first. Next tape the long sides. Reinforce by placing tape around the corners. Put dividers in as needed.
3 Cut a 13½" × 9½" (34cm × 24cm) piece of batting material for the bottom of the box. This helps to keep pastels from rolling around.
4 You can wrap a small bungee cord around the top of the box to transport. If you use this to transport your pastels, add another piece of batting to cover the pastels to keep them from shifting.

ORGANIZE YOUR PASTELS

My pastels are organized in color family groups. Within each group, I arrange them from light to dark. I combine all brands and sizes in these groupings. As I work on a painting, the pastels that I am using for that particular painting end up in a separate box. This makes them easier to find during a painting session. After a painting is completed, I put them back with the others.

Soft Pastel vs. Oil Pastel

All of the pastels mentioned in this book, regardless of relative hardness, are considered "soft pastel." There is another type of pastel called oil pastel. These have an oil binder and are completely different. I have not found good results combining soft pastels with oil pastels.

Miscellaneous Supplies

Here are some other supplies I have found helpful when I paint.

Lights: I use two lights. One has a Chromalux bulb. I use it to light my subject. The other is a flexible combination light containing a Chromalux bulb as well as a circular incandescent bulb. I use this to light my painting and supplies. This allows me to have consistent lighting no matter when I paint.

Easels: I have three easels: a large, sturdy one made of wood, a French easel for traveling and a small, portable, aluminum easel. I find that the inexpensive aluminum is the most efficient for works under 24″ × 30″ (61cm × 76cm). Because it's lightweight, I can move it easily around the studio. As I paint, I shift from standing to sitting to a sit-stand position. I like to keep my work at eye level. This easel is quick and easy to adjust as I move.

Chair: I use an adjustable chair on rollers so I can move closer to or away from a painting to see how it's progressing.

Safety Gear: Pastels create a fine dust, so using a filter and a mask can reduce the risk of irritation. Use finger cots to cover your fingers and thumb to protect the skin. They work better than gloves, which can be bulky and make your hands sweat. Both the masks and finger cots can be purchased at medical supply stores.

Some artists also use air filters to draw pastel dust particles down and away. To minimize problems with dust, work upright and don't try to blow off excess pastel. The first thing you do when you blow is inhale, breathing in particles. If you need to get rid of excess pastel from your painting, tap it off into a trash can.

Other art supplies: You'll also need Masonite board, clips, newsprint, paint brushes, odorless turpentine or mineral spirits, sketch pads, charcoal, stumps and a kneaded eraser.

REMEMBER TO SKETCH!

I cannot emphasize how important it is to always have a sketch pad around. Drawing and sketching are key to keeping your work fresh and growing. I use sketches to see if an idea is going to work before I commit to a final surface. I can also solve problems in compositions and values. I use vine charcoal, stumps and kneaded erasers for charcoal drawings and studies. I do not use kneaded erasers to erase passages of a painting because they tend to change the tooth of the surface.

BRUSHES

I use two different paint brushes. I use a 1-inch (25mm) soft bristle synthetic brush for toning a ground. Use a brush that is as soft as possible. If a brush is too stiff, it will damage the tooth of the surface before you even get started painting. I use a small soft bristle fan brush (the softness of the brush is more important than the specific size) to lightly brush pastel off an area that is not working. Do this sparingly to avoid damaging the tooth.

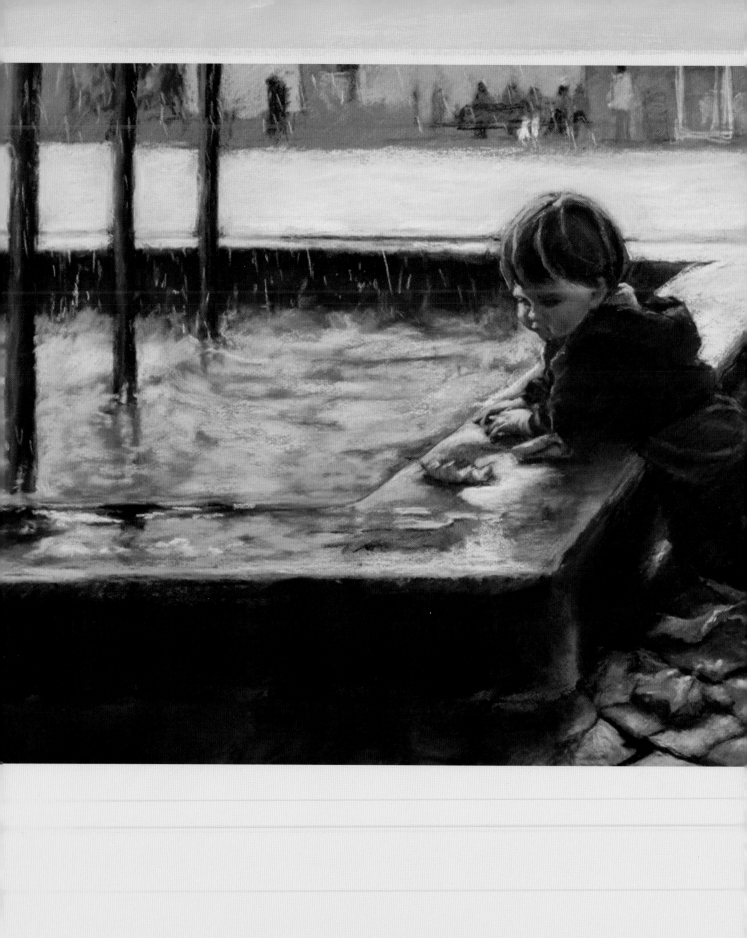

2 Choosing Subjects *and* Reference Materials

Some say there is nothing new under the sun. I have often had the experience of being so excited about a new idea just to open an art publication and find the same idea painted in glossy color. Many artists worry that everything has already been painted. It probably has, but not by you. Just the fact that no two faces are the same will set your work apart from another artist. To further personalize your portraits, use props that have meaning to your subject. Use props and backgrounds that inspire you.

Early on in my career, I was asked what I was trying to say in a painting. I had nothing to say. I basically felt I was painting what I wanted. However, I started thinking about what I really wanted to paint and why. I want to paint because I am excited or moved by the way light hits and changes colors as it travels across a subject.

As an artist, you may find it difficult to express what you feel in an oral or written statement. Your concept or vision could be as simple as a connection to beauty or light. Paint what you love. When searching for ideas, think in terms of how children develop speech. They begin with single syllables that turn into words. The words become small phrases, then short sentences, then they talk so much we would like a moment of silence. Your ideas or concepts will be like this. Start out small and simple, and one idea will spring from another.

OBTAINING GOOD REFERENCE PHOTOS

One of the biggest challenges that I encounter as a teacher is trying to help artists who come to class wanting to paint portraits from poor-quality reference photos. They are setting themselves up for failure before they begin. Good reference photos will save you time, energy and frustration.

I use film and digital SLR cameras with zoom lenses. Outdoor or natural light is best. When this is not available, I use a lamp with a reflector, but I am never as happy with the outcome from these photos. When I work outdoors with children, I work in the morning between 9 AM and 11 AM. or in the afternoon between 2 PM and 4 PM. When I shoot indoors, I try to find a window so that I can still take advantage of natural light. If you rely on photographs as I do, it is a good idea to take color notes: Jot down the general color of the main areas of the flesh and also of the shadow.

FINDING GOLD
Pastel on Ampersand Pastelbord
11" × 14" (28cm × 36cm)

Composing the Scene

Although the most important aspect of a portrait is the likeness, there are other things to consider for making the painting work. One of these is composition. Planning ahead will save time later. The first thing to decide is where to place the focal point. Another thing to consider is how much room you will leave at the top, bottom and sides of the painting. Remember, you always want to lead the viewer around the composition and back to the focal point. Here you can see the three compositional designs that I use the most. I like simplicity.

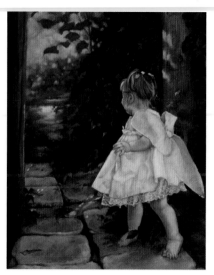

DREAM GARDEN
Pastel on Le Carte
26" × 22" (66cm × 56cm)

THE BASIC S OR Z

This painting of a butterfly heading into a dream garden is an example of an S or a Z composition. The little girl's face is placed on the lower edge of the upper right corner of the composition. Her gaze leads you back into the composition. The light and trail lead you in a graceful S-curve back to the focal point.

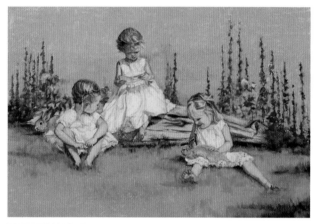

THE TRIANGLE

Triangles keep the viewer inside the painting as their eye moves from one subject to another and back around again. In this painting, the similar white summer dresses and bare feet helped to further connect the figures. I took several photos of each child and placed them in the triangular pattern shown. The two girls on the left are placed closer together, leaving space between them and the girl on the right. I chose poses of the girls looking inward to help keep the viewer moving around the picture plane.

THREE COUSINS
Pastel on Wallis paper
16" × 22" (41cm × 56cm)

Positioning Your Subject

Do not make the margins above and below the main subject even. For example, if you leave 2 inches (5cm) at the top, leave at least 3 inches (8cm) at the bottom or vice versa. Do the same for the sides. This keeps the painting from being too balanced and static.

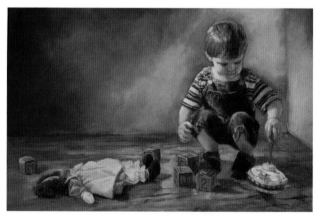

RULE OF THIRDS OR THE GOLDEN MEAN

Dividing the picture plane into thirds both vertically and horizontally to aid in the placement of key elements is a composition technique that dates back hundreds of years. In this painting, the boy's face (the focal point) is placed in the upper right section, while the top (the secondary interest) is located in the center of the lower right third. The doll is in the lower left third. It's a good idea to keep this formula in mind when placing the focal point no matter what compositional design you choose.

THE TOP
Pastel on Ersta Paper
14" × 22" (36cm × 56cm)

Poor-Quality Reference Photos

Choosing a reference photo can make the difference between a painting that requires much trial, error and frustration and a painting that almost paints itself. Here are a few simple things to look for and avoid.

LACK OF CONTRAST

This photo, although sweet, lacks contrast. There are no shadow areas to help define features or create interest. The face is staring straight ahead with flat light. This is the most common error when photographing children. Try to get help in directing the child's focus away from you. This is a nice snapshot for the album, but it would make a dull painting.

DISTANT SUBJECT AND BUSY BACKGROUND

The figure is too small. It's hard to get enough information to paint it. The shadows are too dark. The background is busy and lacks interest. You could possibly solve the background problems with another reference photo taken at the same time with a better view, but the figure still isn't very inspiring. His position is square, and his legs and feet are buried.

TOO MUCH CONTRAST

There is too much contrast of light and dark in this photo of Jr. I made the mistake of placing him directly facing the sunlight. This also caused him to squint in most of his photos that afternoon. Although there is some nice color on the light side, it is a bit washed out. Conversely, the shadow side is flat and holds very little information. With the help of a computer program, it can be lightened, but the color will change. It's better to aim for good photos from the beginning.

Light-to-Dark Ratios

Strive for a 1:2 ratio between light and dark in your composition. Either have one-third of your subject in light, or one-third in shadow. When light and dark areas are equal, the composition becomes boring.

Good-Quality Reference Photos

The most important thing I look for in a reference photo is the lighting. The contrast between light and shadow should be good so that you will be able to model forms well. This is especially true of shadows underneath and to the side of the nose. Good shadows will help you create the appearance of the nose coming out from the rest of the face. I also look for good composition by choosing poses where there is a variety of directional changes.

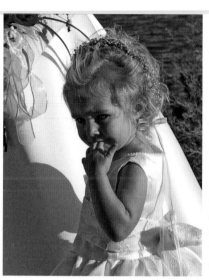

NARRATIVE PHOTO

This photo tells a story, which is a good beginning for a painting. It seems as if this girl is not enthused about her role in this wedding. There are some nice directional lines starting with the angles of her head and arm. The shadows and lights on her face, arm and hand are interesting.

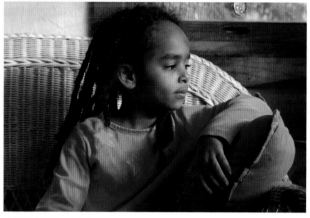

INTERESTING POSE WITH CONTRAST

In this composition, the girl is looking away from the viewer. There is some contrast of light and shadow. The position of her arm and hand adds interest to the overall composition of the photo. There are interesting shapes and colors in the background. This will be a fun one to paint.

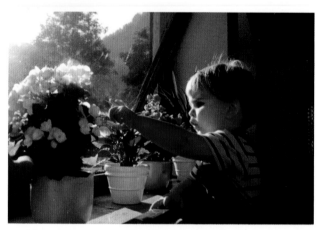

PHOTO PERFECTION: NARRATIVE, INTEREST AND CONTRAST

This photo displays all the characteristics needed for a successful composition. First, there is a story going on. Next, the light on the boy's face and hands is interesting. The light is echoed in the flowers and window sill. His left arm leads the viewer to the flowers and back. Finally, the background is subtle but not dull. I didn't change much when painting from this reference (see page 2).

Working With Children

Photographing children is never dull, but it can be a challenge. I have taken over a hundred photos at a shoot and come up with only one that I could work from. Try to put children at ease when you first arrive. Talk *to* them, not *about* them. You can tell some things about their personalities right away, whether they are shy or outgoing. Ask them questions about their favorite toys, foods and pastimes. Know that the first photos will probably be tossed. Consider these practice. Using a zoom can help alleviate nervousness. Let them play while you stand back. When they relax and forget you are there, you can zoom in and take candid shots.

Capturing Hands in Reference Photos

Hands help tell the story in a composition. They are also a window into the personality of the subject. I try to capture something unique to the subject, something that will help show the character. When photographing children, it is important to take separate shots of their hands.

POOR-QUALITY HAND REFERENCE PHOTOS

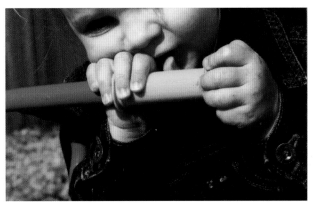

LACK OF DEFINITION

The hands in this photo lack the highlight that would give them better definition. The fingers are all going the same direction, which lacks interest. Because the hands are coming forward, they appear too large for the little girl. They also give the impression that she isn't very comfortable.

TOO SIMILAR AND STUBBY

This reference of a little girl grasping the handlebar of her bike lacks interest. The hands are too similar in overall shape. Although there is some contrast of light and shadow, there isn't any on the fingers to aid in modeling them. These hands risk looking stubby in the finished painting.

GOOD-QUALITY HAND REFERENCE PHOTOS

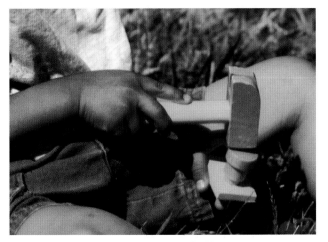

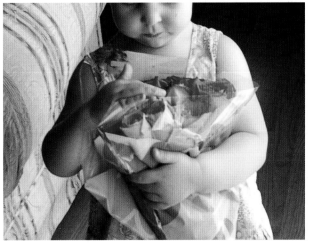

INTERESTING SHADOWS AND ANGLES

Most little boys love to hammer. Although this would be a challenging view to paint, I like the bright yellow against the boy's rich dark skin. I also think there are some interesting shadows and angles.

BEAUTIFUL CONTRAST AND COLOR

This little girl is holding the bouquet of flowers she got for her mother for Mother's Day. I really liked the contrast of the violet against the orange and the way her hands gracefully hold the flowers. See the painting of her hands on page 74.

Combining Reference Photos

As an artist, you have the freedom to move or change things as you please. Sometimes it takes more than one photo reference to make a pleasing composition. This is especially true when you want more than one figure in your painting. In my experience, when photographing more than one child, you are lucky to get a good pose of one, much less two. For the painting on the next page, I combined four photos. Be sure to use reference photos from the same sitting or at least from the same time of day and light conditions. Otherwise, you might find shadows competing for direction. I took many photographs before I came up with the ones I chose to use.

When combining photo references, make several sketches. These will help you make decisions about placing the figures and other elements before you begin painting. I do not compose my photos on the computer because I believe that sketching helps me to stay in touch with the life of the portrait. Drawing is the beginning of the painting process.

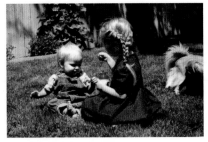

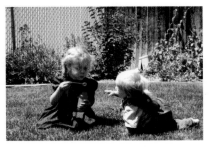

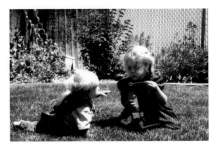

1. ONE FIGURE HERE...

This is the pose I chose of the little girl blowing bubbles. I like watching her in the midst of blowing a bubble. Her hands are also in a pleasing position. I was also attracted to the way the sun hit her braid.

2. ANOTHER FIGURE THERE...

I like the pose of the little boy and the look on his face as he stretches to catch a bubble. The way the sun hits his hair and shirt is also appealing.

3. FLIP THE IMAGE

Because of the position of the little girl, I chose to flip the image of the boy. This way he is reaching for the upcoming bubble.

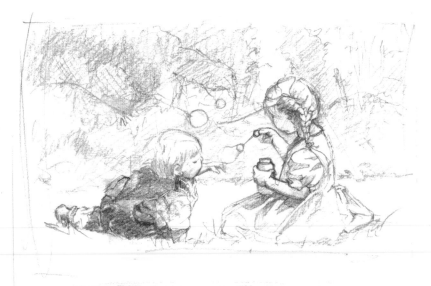

4. A SEPARATE BACKGROUND

For the background, I chose a flower garden. I felt that the fence in the original photo wasn't interesting.

5. VOILA! A FINAL SKETCH

This is the final sketch that I chose to use for the painting. The little girl will be the focal point, so I have placed her face at the edge of the upper corner. The overall compositional design is that of a triangle. By making sketches, I can determine whether I want a horizontal or vertical format. I can also decide on size and dimensions at this time.

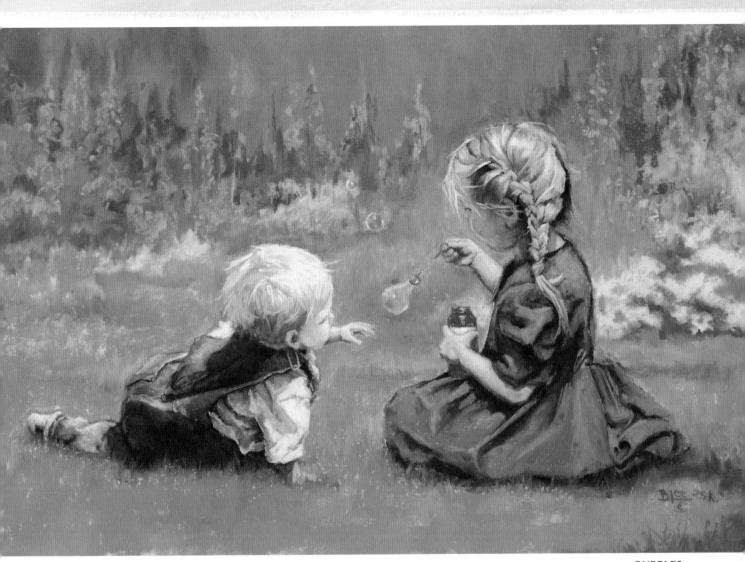

6. FURTHER SIMPLIFICATION

As this painting progressed, the flower garden became too busy and overwhelmed the children. I brushed it off and repainted it by just suggesting vegetation in the background.

BUBBLES
Pastel on Wallis Sanded Pastel Paper
11½" × 18" (29cm × 46cm)

Working From Life

Although painting children often requires working from photographs, I would highly recommend working from life as much as possible. All the information you need is right before you. Photos tend to distort images, cause shadows to appear too dark, and change color. Working from life will help you when you must work from photographs.

Vary the Values

Do not paint the same values in every corner. If the values of all the corners in a painting are the same, the painting will look too balanced and boring. It is better to make one light and the other three dark. Or, you can make one dark and the others light. This is also true of midvalues. The idea is to avoid creating equal amounts of any value.

Ideas for Subjects Involving Children

· Tea parties
· Pumpkin patches
· Playing pirate
· Cowboys
· Blowing bubbles
· Playing with toys
· Cooking
· Dressing up
· Holding pets

3

Mapping

I used to spend hours drawing my subject to get it just right. I would then painstakingly transfer it to the final surface and start painting. This created stiff-looking paintings, because I tried to keep my lines. And I was often frustrated to find that something was off. Over time, I realized I had been creating a lot of unnecessary work for myself, so I developed the process that I now use. I refer to it as *mapping*.

I compare the two approaches to differing ways of planning a vacation. For both, you determine where you want to go and reserve places to stay. With the first method, you plan everything to the tiniest detail, leaving room for few (if any) surprises. With the second approach, you have the security of knowing where you are going and that you will have a place to stay each night, but what you do will be decided when you get up each day. This vacation will be much more interesting. I find that my portraits are much fresher when I follow the second method.

In this chapter, you will learn how to map the face. By this, I mean that you will learn to mark the placement of each important element of the face. Using these marks, you will work your way out from the eye, observing and drawing shapes and values as you go. You will not be drawing the face in detail and then filling it in.

ANNA-CLAIRE KATHERINE
Charcoal on Canson Mi-Teintes Paper
13" × 10" (33cm × 25cm)

General Dimensions and Proportions

All human faces exhibit some basic proportions. These are to be used as starting places only. Each face is unique and each pose different, so measure your individual subject to make accurate assessments.

BASIC PROPORTIONS

These general proportions are true for children two years old and older: The eyebrows are about halfway from the top of the head to the bottom of the chin. Younger babies have longer foreheads. Generally, on a full face-forward head, the distance from the brow to the nose and from the nose to the chin is equal. The width of the eye is equal to about half the distance from the bottom of the nose to the chin. The space between the eyes is one eye-width. The hairline to the top of the head is approximately the same distance as the nose to the chin. This varies with hairstyle. Then of course there is the hat factor. When your subject is wearing a hat, and you can't tell where his hairline is, use the brim of the hat to the eyebrows for this measurement.

The ear sits between the eyebrow and the nose and is the same length as the distance from nose to chin.

Remember, these are basic rules to use as tools to determine the positions of the features on your subject. How does the nose-to-chin distance compare to the nose to brow on your model? Is the width of the eye half the distance of the nose to chin, or is it longer or shorter? Nothing beats observation. Although babies differ in their proportions, the basic tools of measuring can be used to determine placement for them also.

MEASURING YOUR SUBJECT

Use the end of your paintbrush to gauge proportions. Start with the big measurements such as half of the whole head, then move on to smaller ones. In the photos below, the distance from the bottom of the nose to the bottom of the chin will be used. For instance, if you use the distance from the bottom of Justin's nose to the bottom of his chin to determine the distance from the eyebrow to the top of the head, you can see that it is about two of these measurements. The smallest rule I use is the width of the eye. You will need to use the full eye or at least the largest eye. These are the general proportion guides to determine where to place features.

HEAD UP

Notice how the position of Justin's head in this pose changes all dimensions. The distance from his nose to chin is now almost twice the distance of the nose to brow. The distance of the eyebrow to the hairline is half the distance of the nose to chin. Notice where the ears are sitting; the top of the ear is now below the nose and the bottom is almost at chin level. It also appears shorter than in a straight pose. Its length is now two-thirds the distance of the nose to chin.

HEAD DOWN

Now that the head is facing downward, the distance between the eyebrow to the nose becomes longer. The nose to chin is about three-quarters this distance. The bottom of the ears is now situated just below the eyes, and the top of the ears is about three-quarters the width of an eye above the brow. The distance from Justin's hairline to the top of his head now becomes the largest dimension. The ears are longer than the nose-to-chin measurement.

Mapping

Try to achieve correct proportions and relationships, but don't drive yourself crazy making them exact. Exact is for a photographic portrait; the goal here is a fresh portrait that captures the feeling of the child. For this demo, I used vine and willow charcoal because they are easy to erase, but usually I use pastel for this process.

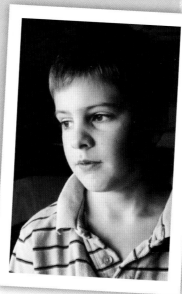

REFERENCE PHOTO: JUSTIN

MATERIALS

PAPER
18" × 14½" (46cm × 37cm) Canson Mi-Teintes, pearl

CHARCOAL
fine vine charcoal, medium willow charcoal

OTHER
stump, kneaded eraser, paintbrush with a thin handle for measuring, newsprint (to place under the drawing paper)

Paper Note

I do not paint on Canson Mi-Teintes as a general rule, but I do use it for my charcoal work.

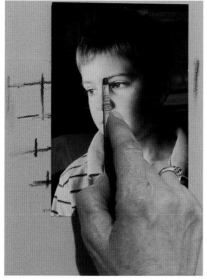

1 Mark the Sides of the Head
With vine charcoal, make a mark at the top of the head. Next, make a mark for the bottom of the chin. After determining the length of the head, use the paintbrush to see how the width compares to the height. Justin's head is about three-fourths as wide as it is tall. Make vertical marks for the right and left sides of the head.

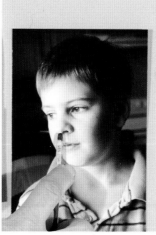

2 Determine the Eyebrow Position
Use your paintbrush to determine where on the face the eyebrows and nose belong. In this portrait, Justin's left eyebrow is a bit less than halfway down on the head. Make a mark here.

Head Placement and Size

Typically, the head should be placed about 3"–4" (8cm–10cm) from the top edge of the paper. Leave more space to the side of the paper where the face is directed. As a rule, the face should not be larger than your hand unless you are making an extra-large statement.

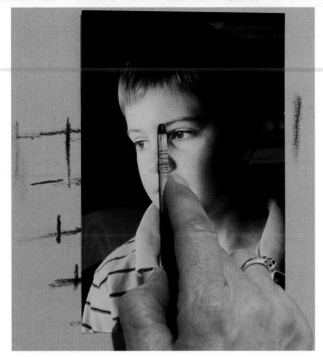

3 Determine the Nose Position

Place the tip of the brush at the beginning of his left eyebrow, then place your index finger on the brush where the bottom of the nose is. Keeping your finger on the brush, move it down so that the tip of the brush is now at the bottom of the nose. This will show you that the distance from Justin's nose to his chin is slightly longer than the distance from the brow to the nose. Take your brush, and, using the distance from the nose to the chin, determine the hairline. Mark the position of the bottom of the mouth. It appears to be just over halfway between the nose and chin. Use the width of the eye lengthwise to determine the distance from the eyebrow to the bottom eyelid. This is about three-quarters the width of the eye.

4 Determine the Angle of the Features

Use your brush to determine the angle of the features. Place the brush along the eyebrows. Then, being careful to keep the angle, move the brush over to your drawing. Mark this angle.

5 Mark the Ear Position

Place a mark for the top of the ear. Notice that it is about half an eye-width above Justin's left eyebrow. Mark the bottom of the ear. It's situated about a third of the width of the eye above the bottom of the nose. You can double-check this by taking the distance from the nose to the chin and checking the overall length of the ear. Justin's ear is just a little longer than his nose-to-chin distance. If the ear on your drawing doesn't match this distance, remeasure and re-mark it.

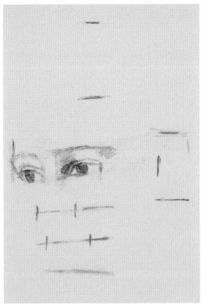

6 Determine Where the Eyes Sit

To determine where the eyes sit, first determine the width of the right eye in proportion to the model's face. Since you know that the width of the eye is generally half the distance from the nose to the chin, you can begin here. This is true of Justin's left eye. Measure the distance from the right edge of the face at the eyebrow to the inside corner of the right eye. Make a vertical mark here. Notice the distance from the corner of this eye to the inside corner of his left eye is a little more than three-quarters of the width of his left eye. Mark this also with a vertical mark. The last mark for the eyes will be the outside corner of his left eye.

Using the brush as a plumb line, determine the far edge of the nose. It comes down from about the center of the white of the eye. Move the brush to his left eye and determine the placement of its edge. See where it comes down from just inside the corner of the left eye. Repeat this process for the edges of the mouth.

7 Double-Check Lengths

Double-check to see if the nose and mouth are the right length by using the width of the left eye. Notice that the width of the nose is a bit longer than the eye. The mouth is also a bit longer.

8 Begin Drawing Facial Features

Using the vine charcoal, draw in the eyebrows. Erase your original placement marks as you go, using the kneaded eraser. From here, draw the shape of the area from the brow to the upper lids. Next, draw the shape of the upper lids. Block in the shape of the irises. At this point, it will be one value; detail and fine tuning come later. Keep it simple at this stage as you may need to erase. Make sure that the corners of the eyes are on the same level.

9 Draw the Nose

Move down the center of the face by modeling the nose. This is done by making the shape of the shadow on the near side, then drawing the far edge and nostrils. Draw in the shapes of the shadow under the left side of the nose and the triangular shape above the upper lip. Continue by drawing the shape of the mouth as a whole. Keep your drawing loose.

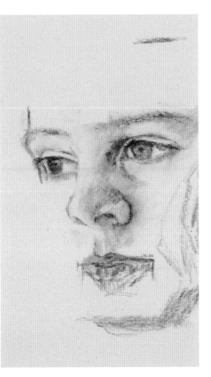

Eye Measurements

To determine the eye-width, measure from the inside corner to the outer corner. Do not use the upper lid or lashes.

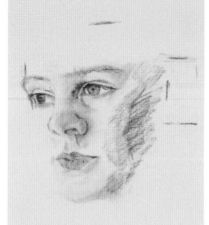

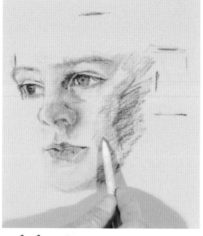

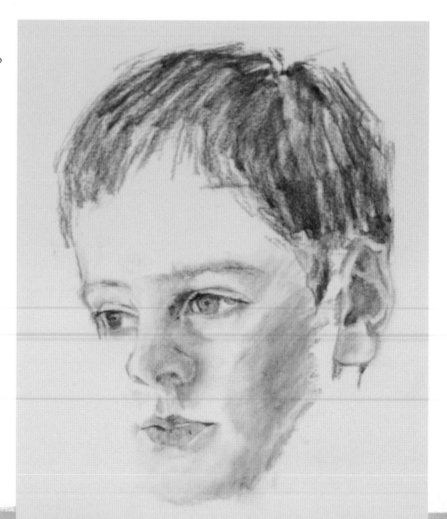

10 Begin Drawing Shadows

Using the vine charcoal, draw the shadow shape on the left side of the face above the brow and on the cheek. Use the willow charcoal to deepen the value on the cheek and jaw closer to the ear. At this time, step back to see if your drawing looks like the subject. If it does, this is the time to start adding more detail to the eyes, nose and mouth. If it does not look like the subject, determine where a change needs to occur. Recheck your angles and measurements. Do not move the chin down or the top of the head up. All of the corrections need to take place between these points.

11 Use the Stump

Use the stump to push the charcoal into the paper and around. Use it at a slant rather than with the tip. You can use the charcoal that is left on the stump after blending the darkest areas to lay on some of the lighter values.

12 Block In the Ear

Draw the dark shapes inside the ear and use the stump to blend them out. Then draw the outside of the ear.

13 Block In the Hair

Block in the hair with the willow charcoal. Notice the angle of the forehead above the unseen right ear. Use your paintbrush to gauge this correctly. Use the stump to blend the charcoal on the hair, following the direction of the strands.

14 Establish the Right Side of the Face

Establish the right side of the face by determining the distance from the edge of the nose out to the edge of the face. Use the width of the eye as a gauge. The distance on the portrait of Justin appears to be slightly less than half an eye-width. Place a mark here. Next, determine the distance from the corner of the mouth to the edge of the face. Finally, use the brush again as a plumb line to determine the bottom edge of the chin and place a mark here. Now you can connect these marks by carefully determining angle changes as you draw from one mark to the next. Since this side of the face is light, use the vine charcoal and a light touch.

15 Add Finishing Details

Draw the left edge of his face the same as the right. Because this distance is greater than the width of the eye, use the nose-to-chin measurement. Bring the neck down from the ear. Draw in the collar on both sides. Notice the right collar hits the face just below the bottom lip. The left collar hits the face at about the center of the mouth. Finish by darkening values where necessary and blending with the stump to achieve the subtle values of the face. Use the kneaded eraser to soften edges and lift light areas. Pinch it thin to lift highlights in the hair.

Knead Often!

The kneaded eraser will get dirty quickly from the charcoal. Kneading it often will help keep the surface clean. Kneading also helps reduce stress!

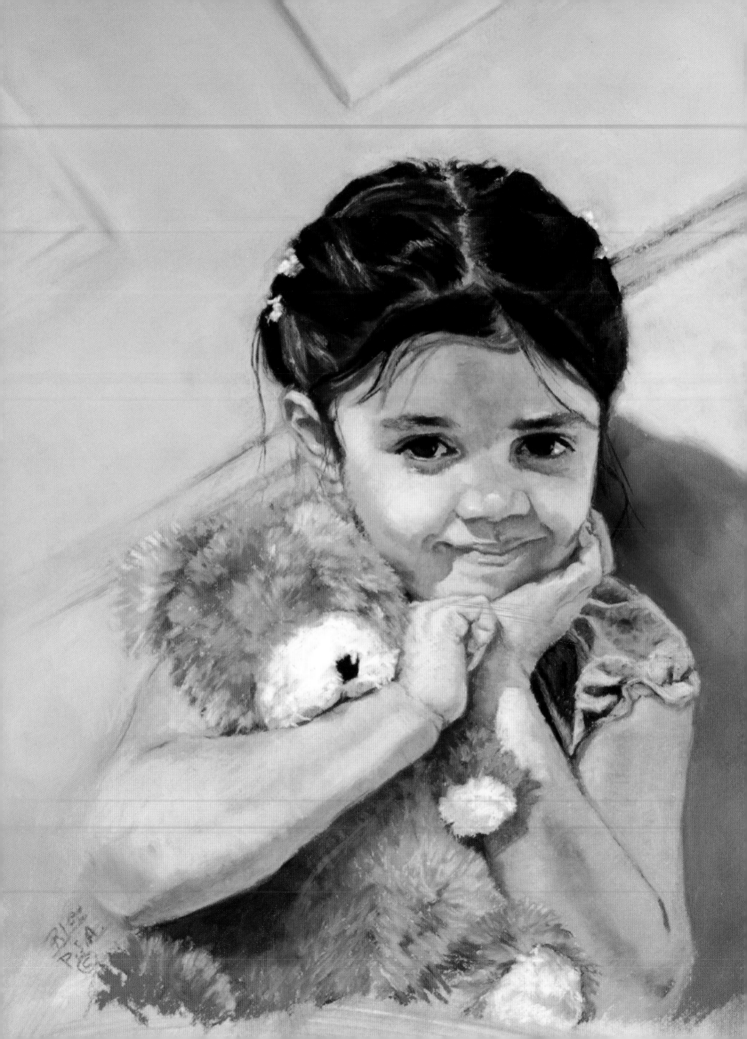

4 Color

Color—what a fun topic! In portrait painting, color is not as important as accurate drawing or correct values, but it can add life and energy to an artwork. I do not advise using a set formula for skin tones. Rather, I encourage you to carefully observe your particular models to determine which colors you see in them. For this portrait of Nadia, I looked for places in her skin to reflect blue from the door. I also added a few strokes of blue to the bear to create unity. With practice and careful observation, you will begin to find new colors in your subject that you didn't see before.

This chapter will provide a foundation for making good color choices. You'll learn how to make a color chart and how to work with various color schemes. Color is such a vast subject that one chapter in one book cannot capture it all—so, study, observe and experiment.

NADIA BY THE BLUE DOOR
Pastel on Wallis Sanded Pastel Paper
15" × 13½" (38cm × 34cm)

Make a Color Wheel

While commercial color wheels are available, it's much more beneficial to make your own. You will be using real pigments and mixing your own colors. This will help you learn what colors will do; plus it will be a more accurate guide to help you in decoding color.

I resisted doing this for years because I just wanted to paint. When I finally broke down and took the time to make a color wheel for myself, color mixing became easier. If I cannot figure out how to make a color, I look at the wheel to see what's close, then determine which hues can be used to obtain it. Make your color wheel with acrylic paint so it will not rub off. Remember that colors vary from medium to medium and from manufacturer to manufacturer; the wheel you create will simply be a reference to help you come close to the colors you need.

MATERIALS

SURFACE
11" × 11" (28cm × 28cm) poster board

ACRYLIC PAINT
Ultramarine Blue, Red (Van Gogh Carmine was about the reddest red I could find), Cadmium Yellow Light

BRUSHES
no. 8 or 10 bright

OTHER
compass, ruler

1 Draw Circles
Set your compass at 4" (10cm) and make a circle in the center of the poster board. Reset the compass at 3" (8cm) and draw the second circle inside the first. Set the compass at 1½" (4cm) for the inner-most circle.

2 Divide the Circles
Using a ruler, divide the circles in half vertically and horizontally. Your drawing should resemble a pie with four large pieces.

3 Make Twelve Wedges
Divide the circle into twelve wedges by marking each outer arc about every 2 ⅛" (54mm). Use your ruler to draw lines connecting these works with the center.

Mixing Neutrals

When mixed in equal amounts, complements (the colors opposite each other on the color wheel) make browns and grays (those in the center ring). The neutrals in this inner circle are all similar to each other. As you move farther from the center, the colors take on more of the character of the color that dominates the mixture. Thus, they make more interesting (and colorful) browns and grays.

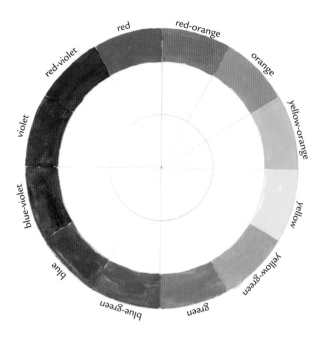

4. Mix Colors for the Outer Circle

Starting at the top, label the outer circumference of the circle as follows: red, red-orange, orange, yellow-orange, yellow, yellow-green, green, blue-green, blue, blue-violet, violet and red-violet.

Paint the red and yellow sections first. Next, mixing the colors half and half, paint the orange space. Split the leftover orange into halves. Add an equal amount of red to one half. Use this for the red-orange section. Add the remainder of the orange to an equal amount of yellow for the yellow-orange. Paint the blue section. Use equal amounts of the blue and yellow to mix the green. For the yellow-green and blue-green, repeat as for the red-orange and yellow-orange. Complete the outer circle by mixing the violet using half red and half blue, then mix the red-violet and blue-violet.

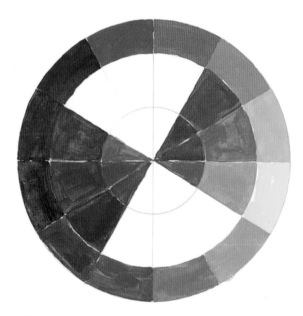

5. Mix Complements to Create Neutrals

Mix equal amounts of yellow and violet. Paint this mixture at the center sections of the yellow and violet. Split this mixture into halves. To one half, add an equal amount of yellow. Paint this in the section below the yellow. To the remainder, add an equal amount of violet; paint this in the wedge under the violet.

Continue by mixing the yellow-orange and its complement blue-violet in the same way you mixed the yellow and violet. Then move on to the orange and blue.

6. Finish the Wheel

Complete the color wheel by following the procedure in step 5 until all sections are filled in.

Color Schemes

Here are the four most common color schemes used in painting. I use the complementary color scheme for most of my work. I try to keep my color schemes as simple as possible.

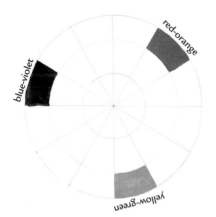

TRIAD COLOR SCHEME

Triads are three colors that are equidistant from each other on the color wheel. In this example, there are three spaces between each color. This is a very common color scheme.

COMPLEMENTARY COLOR SCHEME

Complementary colors are colors that are directly across from each other on the color wheel. This is a very simple scheme to use. I recommend it to beginners because it doesn't require much planning and thinking. I often use the complement of the major color in a subject for toning the surface. For example, if a child is wearing a lot of yellow, I might tone the surface with blue instead of my usual olive green. If a model is wearing mostly blue, I might use a burnt sienna or tan surface.

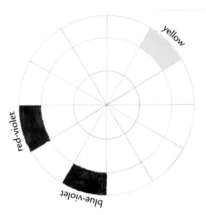

SPLIT COMPLEMENTARY COLOR SCHEME

A split complementary scheme consists of a main color combined with the two colors on either side of the main color's complement.

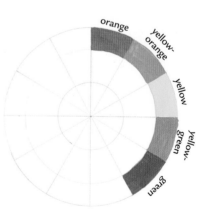

ANALOGOUS COLOR SCHEME

Analogous colors are colors that are next to each other on the color wheel. Limit yourself to only three to five colors for this scheme. When using this scheme, I like to add a dab of the complement to the center color for a bit of a contrast.

Student Assignment

Look at works of art that you admire. Take note of all of the colors that you see in each painting. Decide what color schemes the artists used. This exercise can be an eye-opener. It helps clarify what moves you and helps you understand the importance of using a color scheme in a painting.

Dominant Color

No matter which scheme you use, one color needs to be dominant. This means that you should use more of one color and less of the others in the painting. A good guide to follow is the 1:2 ratio rule.

Mixing Colors With Pastels

It is important to learn how to mix colors with pastels as you would with paint. This is not only useful when your assortment of pastels is limited; it will make your paintings livelier and more interesting.

When painting a portrait, look for places where you can use mixed colors. Pastel can be layered as heavily or as lightly as you choose to mix the colors. You can also lay colors next to each other, or crosshatch them to achieve exciting results.

Even if you have many, many pastels, consider whether a color could be made more exciting by adding another color to it. For example, if you paint something brown and it doesn't seem quite right, would adding some red correct it, or would adding some yellow make it livelier? Experiment and find out.

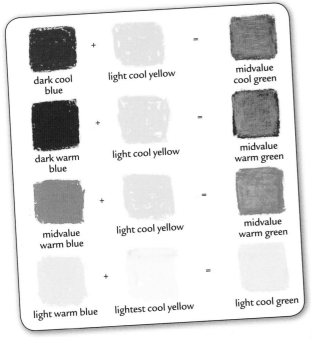

MIXING GREENS

Green is probably the easiest color to mix. There are so many shades of blue and yellow to work with, the sky is the limit—which is great because there is such a variety of green in nature. Tread lightly when adding a third color, but a hint of orange or light warm brown added to a green mixture can make some nice shades of olive and neutral green.

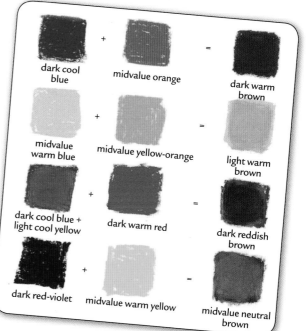

MIXING BROWNS

To make paintings fresher and more energetic, try mixing your own browns and neutrals. Take care not to blend too much, even with another pastel. You can create a flat or muddy look quickly. It is better to make light strokes of one color on top of or beside another and then leave them untouched.

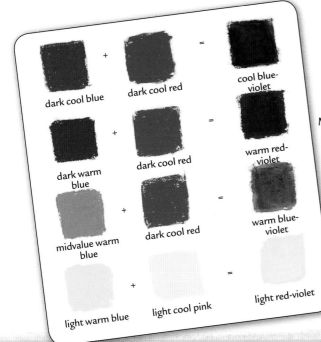

MIXING VIOLETS

Learning to mix your own violets can be helpful in creating unity in a painting. This is especially true when painting shadows. Instead of introducing a totally new color, you can adjust a color already used. Painting strokes of a dark cool blue into a red shirt will quickly establish the shadow areas. Painting a few strokes of a light cool blue over a light pink in a skin tone will be more unifying than painting the same area with a totally different, premade violet.

Temperature

Learning to notice color temperatures is important in rendering a successful portrait. For some reason, understanding temperature in colors was a hard lesson for me. When I thought I finally had it worked out, someone mentioned a warm gray. That threw me off again—isn't gray cold? (See examples of grays below if you need help with this too.)

Before you begin any painting, it is important to decide whether you want the overall feel of the painting to be cold or warm. One temperature should be dominant. Overall cooler paintings give me a feeling of serenity or sometimes even sadness, while warm paintings seem cheerful and more exciting.

COLOR CHART

The colors on the top row of this chart are considered cool colors. The bottom row contains colors that are considered warm. Cool colors tend to recede in a painting, while warm colors will make an object appear to come forward. This tendency can be particularly useful when painting the features of the face.

Challenge

Take some objects that are basically of a secondary color such as a green pepper. Paint these objects by blending and mixing the colors. Paint brown hair without using any brown. Try an eggplant, a cabbage, etc. Small, quick studies will help you to learn to see color and aid you when choosing colors for skin tones. Take care when mixing colors—don't mix too many as this will end up in mud.

RELATIVE COLOR

A color may seem obviously warm or cool, but its temperature may change in relation to the surrounding colors. For example, red-orange would be considered warm. Next to blue, the warmth is apparent, but next to yellow, the red-orange appears cooler. You don't always need to paint an obviously cool color behind an object to make it come forward. As long as the background color is relatively cooler in temperature, it will have the same effect.

DIFFERING TEMPERATURES IN GRAY

Cover the colors on the right. Notice that both colors on the left are gray. Now, uncover the colors on the right. Notice how the blue at the top helps to show that the top gray is relatively warmer than the gray next to the yellow.

Temperature in Shadows and Highlights

If the shadows are warm, the highlights should be cool. Conversely, if the shadows are cool, the highlights should be warm. This is sometimes hard to see in a photo, but, by remembering this rule, you can alter your work accordingly.

Skin Tone Color Charts

COLOR CHART FOR WARM SKIN TONES

Here is a range of colors that is useful for painting children with warm skin tones. See how I used these colors in the painting of Estephan below.

REFERENCE PHOTO: ESTEPHAN

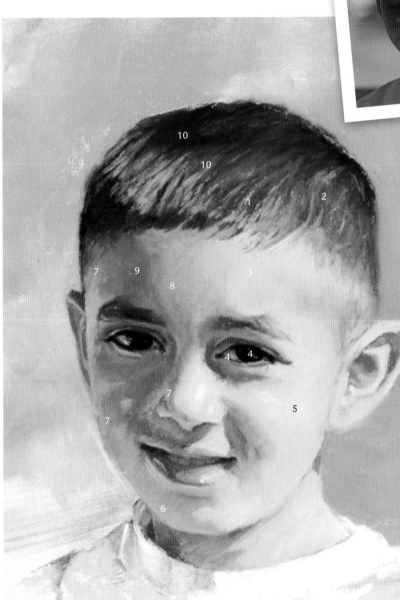

1 Use very light raw sienna to add the very lightest lights in his hair.

2 There are also areas of midvalue red-violet in his hair.

3 His forehead contains some gold and yellow ochre. Paint the lighter areas with midvalue burnt umber, light burnt umber and midvalue yellow ochre.

4 Paint the iris with the dark blue-violet. Paint the whites with midvalue and light blue-grays.

5 The very lightest areas contain some light raw sienna.

6 There is a light blue-gray reflecting from his shirt onto his right cheek and jaw.

7 Some of the lighter shadow areas on his nose, cheek and chin have midvalue blue-violet, as does the reflected light on his left temple.

8 Use midvalue warm red for the transition area next to the shadow.

9 His shadow areas contain dark blue-violet mixed with warm reddish brown.

10 Estephan has dark hair, but the way the sun is hitting it brings out a lot of warm colors. I started with dark blue-violet and dark blue-black for the darkest areas, then gradated these with a dark brown followed by a midvalue warm brown.

43

COLOR CHART FOR LIGHT SKIN TONES

These colors are useful for painting children with fair skin. See how I followed this color chart in the painting of Cody below.

Blond Warning

There is a tendency to want to paint blond hair yellow. As with everything else, careful observation will show you what color it really is. I generally use light burnt umbers, light raw umbers and light and midvalue raw sienna for blonds.

REFERENCE
PHOTO: CODY

1 Cody has light hair and fair skin. For his portrait, I used midvalue blue-violet, midvalue brown and midvalue raw umber for the dark areas of his hair.

2 His shadows appear to contain a blue-violet and brown mixture, and the transition areas between light and shadow are a midvalue cool reddish pink.

3 There are some nice light blue-gray and light blue-violet areas under the mouth, nose and left eye.

4 For his lips, use a midvalue red with a bit of light blue-violet. For the light area on the lips, use the light pink.

5 There is an area of very light raw umber on his chin.

6 Paint the midvalue areas with midvalue burnt umber and the light areas with light burnt umber, light raw sienna and a light cool pink.

7 Cody's eyes contain dark cool blue with midvalue gray-blue, light blue and an accent of light warm pink.

8 For the lighter areas, use very light raw umber and raw sienna. Paint the brows with the same color.

COLOR CHART FOR DARK SKIN TONES

This range of colors is useful for painting children with dark skin tones. Below you can see these colors at work in the painting of Mawusi.

General Rule for Faces

A general rule to follow is to include some yellow on the forehead, some pink on the cheeks, and a cooler color such as a light raw umber or blue-gray on the chin. This is generally true of all skin tones, though it is more obvious in darker skin tones. In some cases it may allow you to enrich your portraits.

REFERENCE PHOTO: MAWUSI

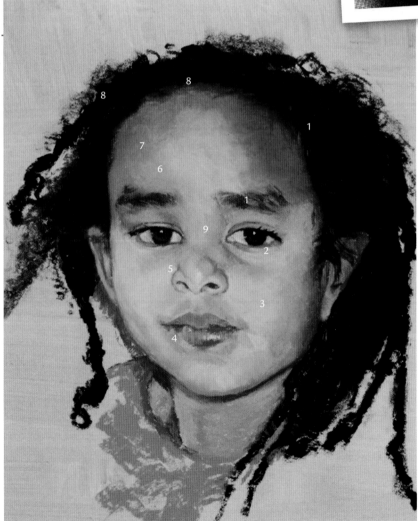

1 For the lighter areas of her hair, use midvalue red-violet. The brows contain the same colors.

2 Paint her eyes with the dark blue-violet and dark brown.

3 For the lighter tones of her face, use midvalue burnt umber, light burnt umber, and light raw sienna.

4 For the areas around her nose and mouth use a combination of midvalue brown and midvalue blue-violet.

5 For some of the shadows on the features, use a midvalue blue-violet.

6 For the transition areas from the shadow to the midvalues, use a warm brown, midvalue red-violet and a warm red.

7 Her face has beautiful, rich color. For the shadows, begin with the dark blue-violet blended with dark reddish brown.

8 For Mawusi's hair, I began with dark blue-violet and dark blue-black, followed by some dark cool brown for the outside edges of the hair.

9 There are some nice gold ochres and warm midvalue browns on her forehead and around her nose.

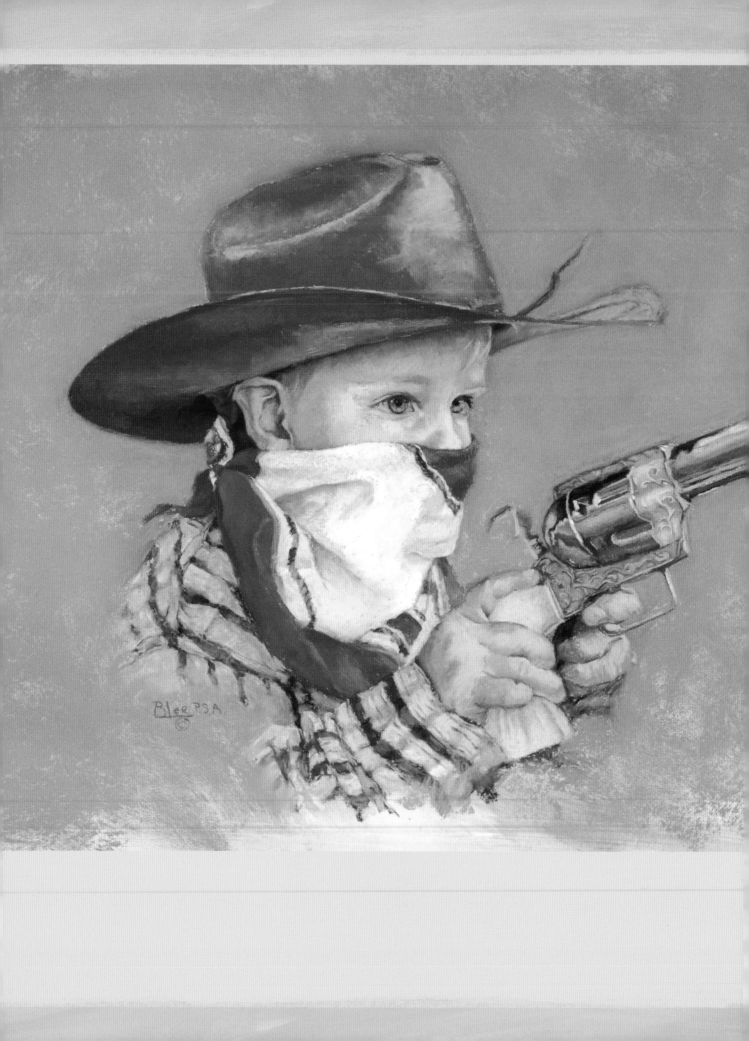

Painting *the* Face

Painting faces, especially children's faces, can be a challenge to most artists, but the rewards are worth the time involved in learning and practicing the skills necessary to achieve a successful portrait.

When you paint a flower or an onion, no one is going to question whether that flower or onion looks like the one in front of you. This definitely is not the case with portrait painting. A good portrait needs to resemble the subject. Ideally, it also should capture the subject's personality or essence.

This sounds like a tall order, and it is—but it's not impossible. By taking things one step at a time, you can avoid becoming overwhelmed and feeling like you want to give up. You've already learned how to map a face to correctly place and proportion the features (see chapter three). In this chapter, we will break the face down into parts, learning to see each feature as a set of abstract shapes with distinct values and colors. We'll examine how the edges of those shapes change, depending on whether they are in light or shadow. We'll study how values help to create the illusion of form and depth on a two-dimensional surface. We'll learn how to fit the pieces together to form a cohesive whole.

By practicing these techniques, you can learn to create an accurate likeness. Then you can work on capturing the personality of your subject. This process takes time: not only hours of practice, but time spent becoming acquainted with the person you want to paint. I have done many portraits using hired models in a group setting. These sessions helped me practice the fundamentals, but the results are not nearly as satisfying as my work from models I know well. Take time to just visit with your subject before getting down to business. Ask about the person's interests, and carefully observe his or her expressions and mannerisms. Your observations will help you achieve a more lifelike portrait.

CAP GUN
Pastel on Wallis Sanded Pastel Paper
16" × 20" (41cm × 51cm)

The Eye

Samantha loves to pose and takes her job seriously as you can see from this photo. I chose to focus on her left eye in this demo. Her right eye is too much in shadow to show much information, but the left eye has enough shadow between it and the eyebrow to aid in modeling the eye socket.

REFERENCE PHOTO

MATERIALS

SURFACE

6" × 6" (15cm × 15cm) Wallis Sanded Pastel Paper, toned with midvalue olive green

PASTELS

black, blackish brown or red-violet (darkest), blue-gray (lightest and mid-value), blue-violet (midvalue), burnt umber (light and midvalue), raw sienna (light and midvalue), reddish brown (midvalue), sienna, warm brown (light, midvalue and dark), warm pink (lightest), warm red (light and midvalue), yellow ochre (dark)

BRUSHES

small, soft fan brush

When to Use Hard and Soft Pastels

It generally helps to begin a painting with hard pastel such as NuPastel. Hard pastels don't fill the tooth of the paper as quickly as do the softer pastels. This allows you to see if you have captured the likeness of your sitter before moving on to softer pastels that will be harder to remove. The harder pastels can be used with a light touch to mark placements and block in the values of the painting. They may be used for the complete painting if desired.

Softer pastels can be layered on top of the harder pastels using wonderful, deliberate, juicy strokes. Some artists choose to use the softer pastels throughout the painting process.

In the demos in this book I begin with the harder NuPastel and then move on to the slightly softer Rembrandt pastels. I use the Terry Ludwig and Townsend pastels for large areas such as backgrounds. I save the softest pastels for the last touches and highlights. I also use NuPastel and Rembrandt to blend areas of color together. These work well for blending because they do not lay much new pigment down.

1 Determine the Proportions

Determine how wide you want the eye to be. Using the end of your paintbrush, take this measurement and turn it vertically to determine the distance from the eyebrow to the bottom eye lid. Samantha's eye is over one-half as tall as it is wide. Be sure to measure just from the inside corner to the outside corner. Do not include the upper lid where it goes beyond the actual eye.

Use hard pastels such as NuPastel for your first layers so as not to fill the tooth of the paper too quickly. With midvalue blue-violet, lightly block in the shape of the whole socket. Lay down just a few sketch strokes to allow you to see the shape as a whole.

2 Paint the Eyebrow and Upper Lid

With midvalue warm brown, paint in the eyebrow. Next, determine where the upper lid begins. Paint the area from the brow to the lid with midvalue reddish brown. Stroke with an upward motion that follows the direction of the eyelid.

Blending With Hard Pastels

Remember that it is easiest to blend with an extra hard pastel such as NuPastel.

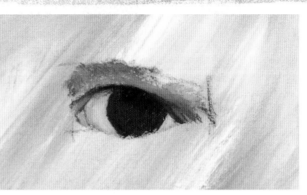

3 Add the Iris, Corners and Whites of the Eye

Using the blackish brown or darkest red-violet, block in the iris. The shape of the iris does not have to be perfect at this stage: Eventually you will redefine it with the whites of the eye. Do remember to follow the curve of the eyeball. The iris is not a full circle; it is cut off by the upper and lower lids. Pay careful attention to the changes in direction as it moves down from the upper lid toward the lower. Use midvalue red or brown to establish the corners of the eye. Whenever you feel that you are losing a shape, go back in and repaint it. The layers add liveliness to the painting.

Use light burnt umber to paint the whites of the eye. It usually helps to draw the shape first, then fill it in. Use midvalue blue-gray to go over the upper part of the white. Use light warm pink to round out the bottom of the white. The white on the outer corner of the eye will just need the burnt umber.

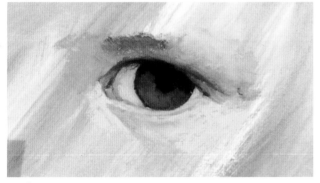

4 Blend and Define

Use midvalue or light raw sienna to blend above the upper lid on the right side of the brow. Paint the light at the inside corner of the eye using light burnt umber or light raw sienna. Paint the lower lid using the light burnt umber. This defines the lower part of the iris. Use a slightly darker value of brown or burnt umber to paint the section of skin under the lower lid. Paint the skin to the left of the eyebrow with a midvalue burnt umber.

Paint the shape of the lighter area of the iris with a warm reddish brown. Repaint the pupil by laying some black over it. Add a touch of dark yellow ochre or orange to add a bit of sparkle to the iris.

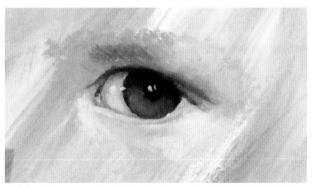

5 Add the Final Touches

The highlights are like frosting on the cake. They make the eye come to life. Be careful to place them well; otherwise, they will not be believable. Do not use pure white. Paint the highlights on the iris with light warm pink. For the highlights on the whites of the eye, use lightest blue-gray. Don't forget the little speck of light on the lower lid. Paint this with lightest pink. Apply these marks by touching the pastel firmly on the paper and drawing your hand back quickly. These marks need to stay fresh, so don't blend them. If you miss, as I did the first time, repaint the section with the same colors as before and take a stab at it again. I found that after the eye was completed, the brow was too dark, so I added a few strokes of a lighter warm brown.

The Mouth

After the eyes, the mouth is my second favorite feature to paint. It is an interactive part of the face; whether speaking or still, it conveys feelings and emotions. The challenge is to keep it fresh by letting the surrounding areas of the face define the structure. Elliana is two and has a beautiful bow mouth. She smiles so much that it was hard to get a photo without teeth.

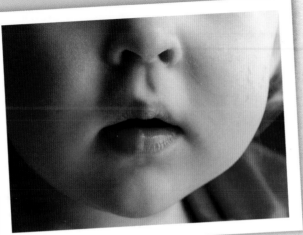

REFERENCE PHOTO

MATERIALS

SURFACE
6" × 6" (15cm × 15cm) Wallis Sanded Pastel Paper, toned with midvalue olive green

PASTELS
blue-violet (light, midvalue and dark), burnt umber (light and midvalue), red (midvalue), red-violet (midvalue, dark and darkest), warm pink (light and midvalue), warm red (midvalue), pink (lightest)

BRUSHES
small, soft fan brush

1 Determine the Proportions
Mark the sides of the mouth. To determine the height, measure from the top left of the upper lip to the edge of the bottom lip. Use a paintbrush to get the correct angle. Elliana's mouth is a little over one-half as high as it is wide. When marking the corners of the mouth, measure from the end of the crease on one side to the end of the crease on the other side.

2 Block In the Dark Shapes
Using dark blue-violet NuPastel, lightly block in the dark shapes on the lips, between the lips, and the shadows above and below the mouth.

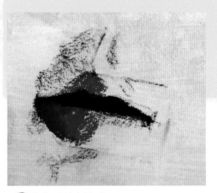

3 Paint With Reds
Paint the lips with midvalue red. Use a slightly softer brand of pastel such as Rembrandt. Paint over the darker parts of the lips on the left with dark red-violet. Make sure to stroke vertically, following the form of the lips. Paint the opening of the mouth with the darkest red-violet. Make a few vertical strokes in the area between the lips with midvalue red-violet to the darkest red-violet.

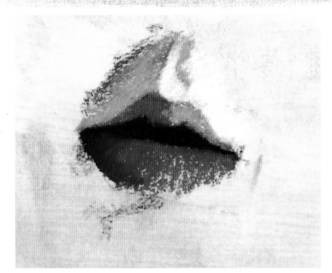

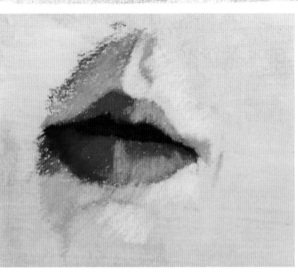

4 Define the Upper Lip

Use midvalue warm red over the shadow of the upper lip. Form the left part of the upper lip with midvalue warm pink. Paint the bow with light blue-violet layered with a light warm pink. Define the right part of the upper lip with light burnt umber. Lighten the right upper lip with warm pink. Paint strokes of slightly lighter warm red over the bottom lip and left side of the upper lip.

5 Define the Lower Lip

Define the lower lip by painting the shape under it with midvalue blue-violet. Layer strokes of midvalue burnt umber over these. Bring some warm red into the shadow on the left. This will help make the lip a part of the face instead of something painted onto it. Paint the lower right side under the lip with light burnt umber. Take some strokes into the lip; this will help it to look natural rather than stiff. Paint the light area of the lower lip with midvalue warm pink and a lighter warm pink. Add some midvalue warm pink above the crease at the right corner of the mouth.

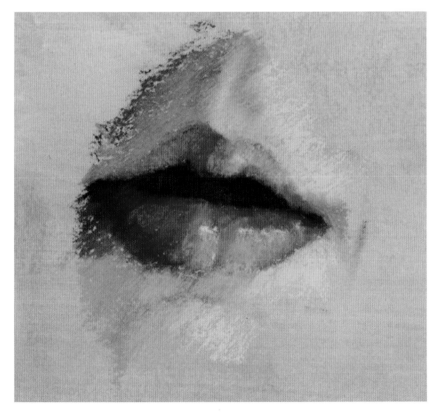

6 Add Finishing Touches

Add midvalue blue-violet to the top of the upper lip and a touch at the middle of the lower lip. Soften the edges above the upper lip by painting strokes of midvalue and light burnt umber to the transition areas between light and shadow. Further lighten the upper and lower parts of the right side of the lips with light warm pink. Carefully place the highlights with the lightest warm pink.

The Teeth

For the most part, I believe that a portrait with an open smile showing teeth makes a painting stiff and frozen in time. There will be times when you may want to paint a portrait this way, or you may have clients who want their child portrayed with a full smile. For that reason, I have included this demo of Anna-Claire smiling.

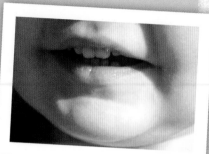

REFERENCE PHOTO

MATERIALS

SURFACE
6" × 6" (15cm × 15cm) Wallis Sanded Pastel Paper, toned with midvalue olive green

PASTELS
blue-gray (light), blue-violet (light, midvalue and dark), burnt umber (lightest, light and midvalue), cool red (midvalue), pink (lightest), raw umber (light), red-violet (light, midvalue, dark and darkest), warm pink (light and midvalue), warm red (midvalue)

Indicating Teeth

When painting a full smile with a lot of teeth, do not draw each separate tooth. It is better to take the color and value shapes as a whole. Create slight separations by making a line at the top and bottom of the teeth instead of drawing a line all the way down.

1 Determine the Proportions
Using the dark blue-violet NuPastel, mark the proportions of the mouth. This mouth is twice as long as the distance from the upper edge of the upper lip to the bottom of the lower lip.

2 Block In the Shadows
Block in the shadows and center part of the mouth lightly with dark blue-violet. Mark the teeth by lightly painting the negative space around them with dark blue-violet.

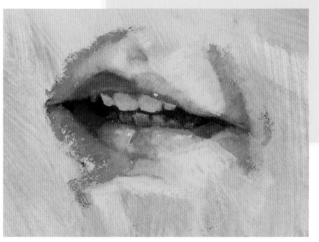

3 Use Warm Values and Refine the Lips
Paint the dark part inside the mouth with the darkest red-violet. Paint the darkest part of the lower lip with dark red-violet. Layer over this with midvalue cool red. Paint the darker area of the upper lip with midvalue warm red. Paint strokes of midvalue blue-violet over the shadow. Glaze this with midvalue warm pink. Paint the upper teeth with light raw umber and the lower teeth with midvalue red-violet. Dab the bow with light blue-violet, followed by midvalue warm pink. Define the edges of the mouth with lightest burnt umber. Paint the light areas of the lips with midvalue warm pink. Add warm pink to the area between the teeth and the upper lip. Paint strokes of light pink and light burnt umber on the light part of the upper and lower lips. Slightly separate the bottom teeth with midvalue red-violet. Stroke midvalue blue-violet over the bottom teeth. Add strokes of light red-violet to the upper part of the upper teeth. Place a few strokes of light blue-gray on the lower edges of the upper teeth. Paint a few light accents with the lightest burnt umber to the lightest areas of the upper teeth.

Add light blue-gray under the chin and above the bow. Blend the hard edges with light burnt umber. Soften the shadow on the right side with midvalue burnt umber.

The Nose

Painting the nose can be the most difficult for me. It helps when the light on the face casts enough shadow to give form to it. Otherwise, the nose can appear flat. For this demo, I chose Mawusi for her rich, warm tones. I also chose a straight-on view to show how you can make the nose come forward by using values carefully. Notice how three basic values—dark, medium and light, with a dab of lightest highlight—make Mawusi's nose appear three-dimensional.

MATERIALS

SURFACE
6" × 6" (15cm × 15cm) Wallis Sanded Pastel Paper, toned with midvalue olive green

PASTELS
blue-violet (midvalue and dark), burnt sienna (light), burnt umber (light and midvalue), gold ochre (light and mid-value), reddish brown (dark), warm brown (midvalue), warm pink (light and midvalue), warm red (midvalue), yellow ochre (light and midvalue)

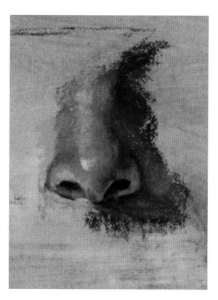

REFERENCE PHOTO

1 **Determine the Nose Length**
Determine the length of the nose with dark blue-violet. Determine the width in relation to the length. Measure from the lighter eyebrow to the bottom of the nose.

2 **Establish the Nostrils**
Using the same blue-violet, lightly block in the shadow shapes. Establish the shape of the nostrils and bottom of the nose at this time. Paint the shadow side of the nose with dark reddish brown. Glaze over the lower right side of the shadow with midvalue blue-violet.

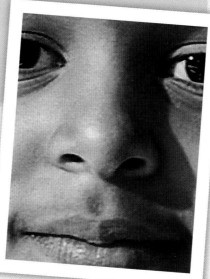

3 **Apply More Color**
Apply midvalue gold ochre to the center of the nose and the upper section of the lighter nostril. Add light gold ochre and light yellow ochre to the center. Layer midvalue yellow ochre, midvalue burnt umber and light warm pink on the ball of the nose. Paint the lighter nostril with light warm pink and light burnt umber. Begin the shaded nostril with midvalue red, glazed with light warm pink. Blend the colors with midvalue burnt umber. Paint Mawusi's right cheek with light burnt umber. Lay some light strokes of midvalue red over the shadow side.

Step back to see if the shapes are right and fix anything that doesn't appear correct. The nostrils usually need a little tweaking at the end of a painting. Soften the line between the midvalue and dark of the shadow. Add the highlight of lightest burnt umber on the end of the nose.

The Ear

The ear is another challenging part of a portrait. Learning to simplify the shapes and limit the values to dark, medium and light will help. It also helps to remember that the ear is a supporting character in the face and shouldn't be painted with as much detail as the other features. Take care determining the angle of the ear because it can be deceptive.

MATERIALS

SURFACE

6" × 6" (15cm × 15cm) Wallis Sanded Pastel Paper, toned with midvalue olive green

PASTELS

blue-violet (midvalue and dark), burnt sienna (light), pink (light), burnt umber (light and midvalue), red-violet (midvalue and darkest), reddish brown (dark), warm pink (light and midvalue), warm red (midvalue)

BRUSHES

small, soft fan brush

Practice, Practice, Practice!

Spend time filling pages of your sketch book with features until you are confident. Draw pages with just noses in every conceivable position, then mouths, ears and eyes. Then try blocking in the three basic values on your sketches

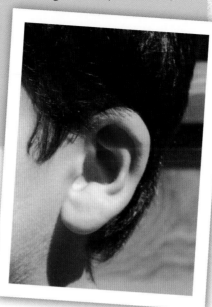

REFERENCE PHOTO

1 **Determine the Proportions**
With dark blue-violet NuPastel, mark the top and bottom of the ear. Next determine how wide the ear is at its widest. It appears to be about one-half as wide as it is long. Use a small fan brush to gauge the angle of the ear. The ear has a lot of angles, so it is important to determine the inner and outer ones.

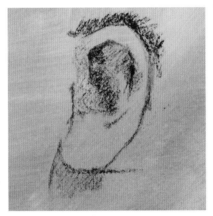

2 **Block In the Darks**
Block in the darks with dark blue-violet. Add a bit more pressure as you paint the darkest area of the inner ear.

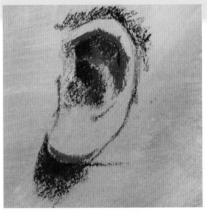

3 **Define the Value Changes**
Paint over the darkest area with dark reddish brown. Paint warm red on the darkest parts of the outer ear. Begin to define the value changes inside with midvalue blue-violet and midvalue red-violet.

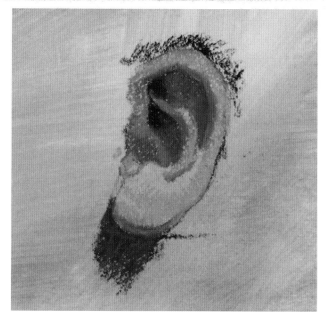

4 Paint the Midvalues

Paint the midvalue shapes on the lower lobe and along the upper edge at the top of the ear with midvalue warm pink. Paint the lighter areas of the inner ear with midvalue warm pink. Glaze over this with midvalue red-violet. Paint strokes of midvalue warm red into the shadow of the inner ear and the shadow under the ear.

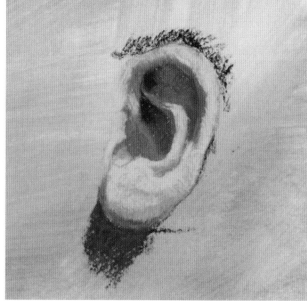
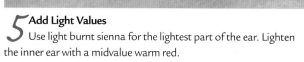

5 Add Light Values

Use light burnt sienna for the lightest part of the ear. Lighten the inner ear with a midvalue warm red.

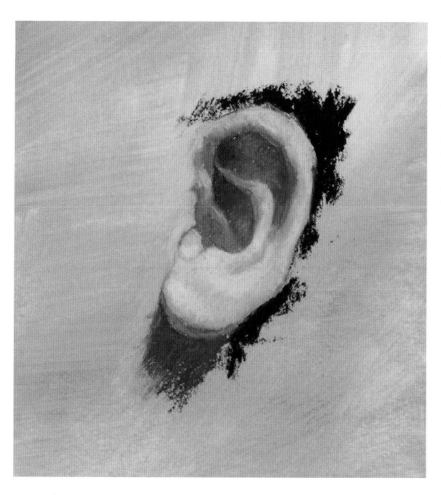

6 Add Finishing Touches

Lightly blend the areas of differing values on the lighter part of the ear with light burnt umber and light warm pink. Use midvalue warm pink to blend the edges of the outer ear. Further define the outer ear by painting a bit of the dark hair with strokes of darkest red-violet. Paint the skin of the face to the side of the ear and under the lower shadow using midvalue burnt umber. Add light burnt sienna to the lower part of the inner ear.

Curly Hair

Elliana not only has a bow mouth, but also has naturally curly hair—a wonderful combination. Painting curly hair takes a bit more concentration than painting straight or wavy hair. It helps to begin with one section, work the dark, medium and light, then move on to the section next to it.

REFERENCE PHOTO

MATERIALS

SURFACE

9" × 9" (23cm × 23cm) Wallis Sanded Pastel Paper, toned with midvalue olive green

PASTELS

blue-gray (light and midvalue), blue-violet (light and dark), brown (dark), burnt sienna (lightest, light and midvalue), burnt umber (light, midvalue and dark), cool brown (midvalue), gold ochre (midvalue), raw umber (midvalue), red-violet (darkest), warm brown (light and midvalue)

Simplify the Hair

Simplify the hair by choosing what you feel are the most important areas rather than painting every curl and strand. This will keep the hair lively.

1 Block In the Dark Shapes

Begin with the upper left corner of the section of hair. Lightly block in the dark shapes with dark blue-violet.

2 Add Darkest Values

When you are certain of the shapes, paint over them with darkest red-violet.

3 Establish the Midvalues

Overlap the darkest red-violet with dark brown, then overlap this with a midvalue warm brown for a gradual transition of light and color. Use midvalue raw umber and midvalue warm brown to establish the midvalue section of the hair.

4 Start Drawing Curls and Add Negative Shapes

Draw in the strands of curl with light warm brown. Add light burnt sienna to the middle section of the strands that are catching the light. Continue working the hair, painting the section to the right of the one just completed. Glaze over the cool areas with midvalue blue-gray.

Continue painting the group of large curls at the lower left by painting the negative shapes with dark brown. Bring the light curls at the upper right across the head with light warm brown and light burnt umber.

5 Establish the Main Curl and Create Additional Curls

With dark brown, establish the shape, angle and length of the main curl at the bottom. Paint the left side with dark brown, followed by a midvalue warm brown. Stroke in the direction the hair flows. Paint the right side of the curl with a midvalue cool brown, followed by mid- to light-value warm brown.

With dark brown, continue establishing the shape, angle and length of additional curls. Paint the left side of each curl with dark brown, followed by a midvalue warm brown. Stroke in the direction the hair flows. Paint the right side of each curl with a midvalue cool brown, followed by midvalue raw umber and midvalue warm brown.

6 Refine the Curls

Darken any areas that have become too light. Define areas where the curls separate with dark brown. Add warm brown and midvalue gold ochre to the warm areas of the strands. Use the lightest burnt sienna for the accent areas where the light hits. This will help give direction to the curls. Paint the skin around the hair with the midvalue burnt umber. Paint the shadow from the hair on the right side with light blue-violet, glazed with midvalue burnt umber.

Straight or Wavy Hair

Elijah has warm, silky hair. I chose this reference because of the warm lights and color gradations.

REFERENCE PHOTO

Clean Your Pastels

Be sure to clean your pastels after each stroke when you are painting one color or value into another. This keeps the painting clean and helps you avoid getting marks where you don't want them. It also helps you avoid the temptation to paint back and forth. Aim to paint a stroke and leave it. By going back and forth, you move pastel where you may not want it.

MATERIALS

SURFACE

9" × 9" (23cm × 23cm) Wallis Sanded Pastel Paper, toned with midvalue olive green

PASTELS

blue-violet (light and dark), brown (dark), burnt sienna (light), burnt umber (midvalue), gold ochre (midvalue), raw umber (light), red-orange (midvalue), red-violet (dark and darkest), warm brown (light and midvalue), warm pink (light), warm red (midvalue), warm reddish brown

1 Mark the Placements and Main Separations
With the dark blue-violet, mark in the basic shape of the hair. Mark the large separations. Choose the main shifts in the direction of the hair.

2 Block In the Dark Areas and Paint the Ear
Using the darkest red-violet, block in the darkest areas over and behind the ear. Paint in the ear at this time using dark red-violet, midvalue warm red, light warm pink, light raw umber and light burnt sienna.

3 Paint the Darkest Area

With dark warm brown, paint in the darkest shapes. The strokes should follow the flow of the hair. Then, add strokes of midvalue warm brown. Paint dark reddish brown to further define the sections of hair. Paint the dark sections at the front of the head and the strands coming down onto his face with dark red-violet and dark warm brown.

4 Paint the Skin Tones

With midvalue burnt umber and light warm pink, paint the areas of the face between the shapes of hair. Add midvalue warm red to the shadow to the right of the hair above the ear. Add midvalue warm brown to the large midvalue sections above the ear, top front of the head and strands. Paint midvalue cool brown on the midvalue sections on the middle of the head.

5 Add Finishing Touches

Add midvalue and light browns to model the movement of the hair across the top of the head and over the face. Take light warm brown and, with a light touch, bring some fly-away strands over the top of the head. Add some light warm pink and light raw umber highlights to the upper section of hair as it is cooler than the back section. Add warm red and gold ochre to accent a few strands. Paint the lights on the back of the head with light blue-violet in a curved pattern to show the shape of the head.

Dark Skin Tones, Three-Quarters View

Dzifa is the daughter of an artist in my community. I like the way the shadows form the left side of her face. In this three-quarters view, her expression makes you wonder what she is thinking.

REFERENCE PHOTO

MATERIALS

SURFACE
18" × 14" (46cm × 36cm) Wallis Sanded Pastel Paper, toned with midvalue olive green

PASTELS
blue-gray (lightest, light and midvalue), blue-green (dark), blue-violet (light, midvalue, dark and darkest), brown (midvalue and dark), burnt umber (light and midvalue), cool pink (light and midvalue), cool red (midvalue), gold ochre (light, midvalue and dark), olive green (midvalue), red-violet (lightest, light, midvalue and darkest), reddish brown (light, midvalue and dark), warm brown (midvalue)

BRUSHES
soft-bristle fan brush

Achieving a Likeness

Facial proportions such as those from the top of the head to the hairline and from the bottom of the nose to the bottom of the chin remain fairly constant from one subject to another. So, the key to achieving a likeness is noticing the differences in shapes and angles within that framework.

Blocking in the shadow areas and eye sockets is the first step. Next, check for subtle differences: How wide are the eyebrows? How do they angle around the bone of the eye socket? What shape is the eye? How much space is there from the eyebrow to the top of the eye? What is the shape of this space? Is there a space below the crease of the upper eye, or does the eye come up to meet the crease? The slant of the upper eyelash is also important in defining the upper eye.

Each nose also has its own personality. Is the tip short, sharp or round? How wide are the nostrils? Are the lips full or thin? Is the separation of the mouth fairly straight or is it more angled? Are there dimples? Are the cheeks high? Are they full? What shape are the ears? How are they placed?

The important thing is to learn to see shapes and values. By painting the shapes around a feature well, you will paint the feature itself well. Let the value changes help you define each of these subtleties in your portrait.

1 Map the Face
With a hard blue-violet NuPastel, map the face as shown in chapter 3. The distance from brow to hairline is the same as that from the brow to the bottom of the nose. The distance from the bottom of the nose to the chin is shorter than from the nose to the brow. Take care with the tilt of her head. Use your paintbrush to test the angles.

2 Block In the Shadows
With the same dark blue-violet, block in the shadows on the right side of the face. Use your brush as a plumb line to determine where the shadow on the forehead hits the eyebrow and where the shadow on the cheek hits the eye. Continue to block in the shape of the neck, ear and hair. As you work the shadow, you will establish the right side of Dzifa's face.

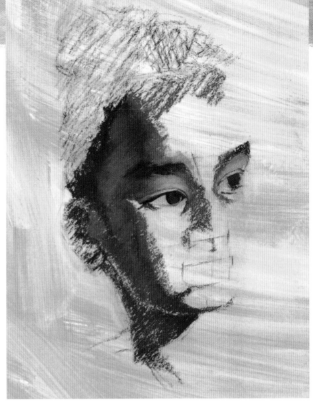

3 Add Color to the Darks

With dark brown, paint in the eyebrows using light, fresh strokes. Do not fill them in solidly. Other than the lashes and pupils, this will be the darkest value on the face. Paint strokes of dark reddish brown on the shadow, slanting them toward the ear. Take the same dark brown from the brows to paint the hair in the shadow. Paint more reddish brown back into the hair so it won't look pasted on. Use midvalue brown to lightly blend the strokes of reddish brown. Use midvalue to dark blue-violet along the right edge of the shadow as this is the darkest part. Use dark blue-green under the dark reddish brown for the shadow under the chin and on the neck. Use reddish brown to paint the shadow between the right eye and the nose, and the shadow beside the nose.

4 Paint the Eyes

Use midvalue reddish brown to paint the shape from the eyebrows to the upper eyelids. Add some midvalue gold ochre to the inside. Use light burnt umber to paint the middle of the upper lid; use light blue-violet to form the far edge. Add a touch of midvalue reddish brown to the near edge of the lid to round it. Paint the irises with dark brown.

With mid- to light-value blue-gray, define the shape of the irises by painting the shape of the whites of the eyes. Use midvalue reddish brown to paint the near left side of the nose. Use darkest blue-violet to paint the eyelashes. Paint these as a unit and not separately.

5 Add More Color

With midvalue reddish brown, add a layer of color next to the shadow on the forehead and nose, toward the center of the face. Add a layer of mid- to dark-value gold ochre. Paint the dimple on the forehead over her right eyebrow by using blue-violet layered with reddish brown.

Strokes Follow Form

Paint your strokes in a direction that follows the form of the face. On the side of the nose, the strokes should be painted at an angle from the edge of the nose down toward the cheek.

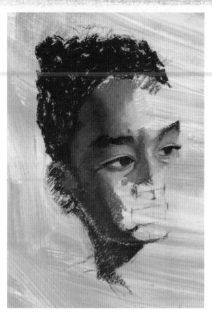 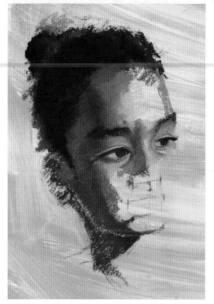 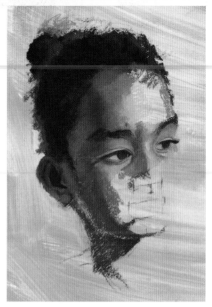

Scumbling

Take the side of a pastel, preferably a hard one, and lightly graze the surface. This will lay down a very thin layer over what has already been placed.

6 Paint the Hair

Block in the shape of the hair with dark brown. Use midvalue red-violet to give the bun and top of the hair some definition. Blend this color in at the hairline also. Add the darkest red-violet back into the hair where you see the darkest darks. At this time you can also use a midvalue cool red to establish the left side of the face so you can paint the wisps of hair there. With a scumbling stroke, paint the outside edges of the hair with midvalue olive green combined with midvalue brown. Do this with a light touch so you will be able to see the background behind the wisps.

7 Paint the Ear

Using the dark brown, paint the shape of the inside of the ear. Model the form by painting a slightly lighter shade of blue-violet next to this. Use dark brown for the line of definition on the outer ear. Paint the rest of the shape of the ear using midvalue reddish brown. Lightly glaze midvalue olive green over this.

8 Paint the Nose and Mouth

Using reddish brown, define the shadow of the far nostril. Paint another layer next to this with midvalue reddish brown. Paint the near nostril with dark brown. Go over this with dark reddish brown. Paint the far nostril with midvalue reddish brown. Add midvalue red-violet between the nostrils. Start combining the layers of the top of the nose by painting strokes of the same colors back and forth into each other. Paint the ball of the nose with a combination of midvalue reddish brown and midvalue gold ochre. Paint midvalue reddish brown on the bow of the upper lip. Loosely draw the upper lip, then paint the lips as a whole shape using midvalue cool red. Use dark blue-violet to separate the lips. Add some of this to the near side of the upper lip. Paint the skin above the lips with midvalue brown, layered with mid- to light-value reddish brown.

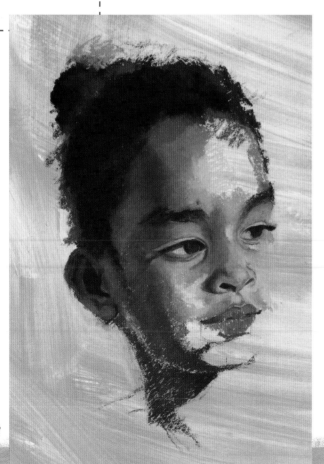

Work the Hair Before Finishing the Face

Once you've established the form of the eyebrows, eye sockets and nose, work the forehead and hair before you go back and complete the facial features. This method will help you avoid having pastel sift down from the hair onto a finished face.

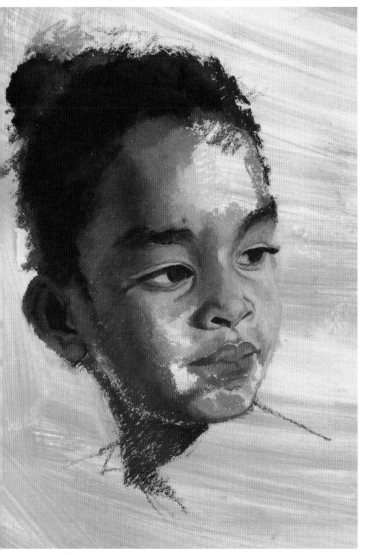

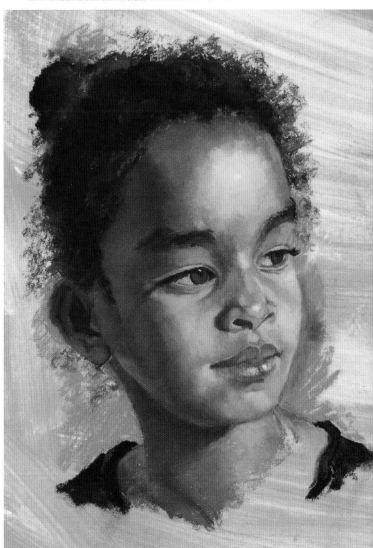

9 Paint the Chin and the Far Side of the Face

Using midvalue reddish brown, paint the area next to the shadow on the near side of the chin. Use midvalue brown and midvalue blue-violet to define the lower lip. Use midvalue brown to paint from the bottom of the chin to the lip. Paint the light value of the chin with midvalue brown and burnt umber. Paint the area under the far eye with light red-violet and light blue-violet. For the area below this, begin with midvalue gold ochre. Paint into this with a midvalue burnt umber and midvalue reddish pink. Paint the area under the near eye with the same, but add a bit of yellow ochre in the middle. Define the far edge of the face with midvalue reddish pink.

10 Paint the Neck and Shirt and Finish the Details

Using mid- to dark-value blue-violet, paint into the shadow on the neck. Next to this add midvalue reddish brown. Paint the area under the chin with dark gold ochre. Paint the areas on both sides of the back of the neck with midvalue red-violet.

The shirt is painted with the darkest blue-violet. Add the light reflections with midvalue red-violet.

Add light cool pink and lightest gold ochre to the light on the forehead and on the area of the nose between the eyes. Put a touch of light gold ochre on the ball of the nose. Add light cool pink to the edge of the mouth on the left. Repaint the mouth with midvalue cool pink. Add the highlights on the mouth with lightest red-violet. Dot the highlights in the eyes using the lightest blue-gray. Dab the lightest highlight on the lip with the lightest pink. Use midvalue olive green to clean up the edges around the right side of the face. Use dark olive green at the lightest area of the far side. Carry this olive green to the near side as well.

DZIFA
Pastel on Wallis Sanded Pastel Paper
18" × 14" (46cm × 36cm)

Medium Skin Tones, Front View

Elijah is the grandson of the nationally known artist Robert Harper. His father is from Malaysia. When I went over to photograph him and his brother, they were wearing their Chinese New Year costumes. I thought the bright red clothing and hat would make a great addition to the book.

REFERENCE
PHOTO

MATERIALS

SURFACE
18" × 14" (46cm × 36cm) Wallis Sanded Pastel Paper, toned with midvalue olive green mixed with a bit of warm brown

PASTELS
blue-gray (light and midvalue), blue-violet (light, midvalue, dark and darkest), brown (midvalue and dark), burnt sienna (lightest and light), burnt umber (light and midvalue), cool pink (lightest and light), cool red (midvalue and dark), gold ochre (light, midvalue and dark), olive green (midvalue), raw umber (midvalue), red-violet (midvalue dark and darkest), reddish brown (dark), warm brown (midvalue), warm pink (light and midvalue), warm red (light and midvalue), yellow ochre (light and midvalue)

1 Map the Face
Map the face as shown in chapter 3. Use the rim of the hat for the hairline measurement. Because of the slant of the face, determine the proportions by using the distance from the eyebrow on Elijah's right down to the bottom of the nose. It is about the same as the distance from the nose to the chin. Note that Elijah's eyes are set a bit wider apart than an eye-width. Mark the width of the band on the hat.

2 Block In the Shadows
Block in the shadows on the face with dark blue-violet. Mark the eyes a bit darker. Block in the shadow on the hat. Darken the eyes with darkest red-violet. Paint the eyebrows with dark brown. Begin to paint the shapes around the eyes with midvalue blue-violet and midvalue warm red. Add midvalue blue-violet and midvalue red-violet to the shadow on the left side of the face.

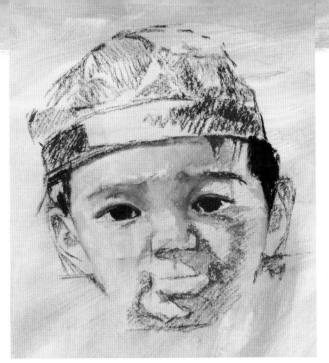

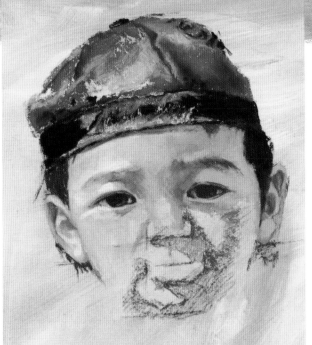

3 Paint the Sides of the Hair

Paint the sides of the hair with the darkest red-violet, leaving the lighter area of the hair on Elijah's right free of pigment. Add red-violet to the inside of Elijah's left eye and warm red and warm pink between the eyes. Paint some strokes of midvalue blue-violet on the shaded side of the forehead. Paint a line of midvalue warm red under the rim of the hat. This will make the hat appear to be sitting on the head instead of being part of the head. Paint strokes of midvalue gold ochre and midvalue burnt umber on the light side of the forehead. Add a few strokes of dark gold ochre and midvalue gold ochre to the sides of the face.

4 Paint the Hat and Forehead

Using the darkest blue-violet, paint the shadow areas of the hat band as well as the button on top and the shadow sections of the crown. Go over the shadow sections in the hat with dark red-violet. Paint dark cool red into this. Add warm red to the lighter areas and midvalue warm pink to the lightest areas. Paint strokes of midvalue blue-gray into the shadows on the band. Then paint strokes of light blue-violet into these.

Paint the lighter part of the hair on Elijah's right with midvalue brown. Paint the darkest areas of the ears with dark reddish brown. Paint over this with midvalue warm red. Paint the lighter areas of the ears with midvalue burnt umber and the lightest areas with light burnt sienna. Elijah's ears are cool, so glaze over the coolest areas with light blue-violet. Paint midvalue warm red and warm pink on the eyelids. Use the light burnt sienna for the lightest area over the right eye. Paint the upper eyelid area of both eyes with dark reddish brown. Shape the irises by painting the area around them with midvalue blue-gray. Paint the lower lids using midvalue warm red and light warm pink.

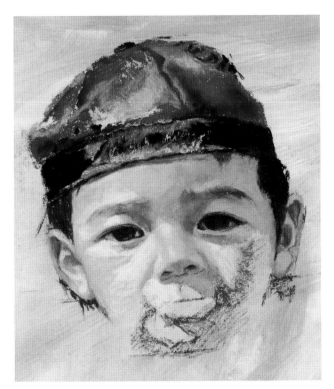

5 Add More Details

Paint under Elijah's left eye with midvalue blue-violet and midvalue warm red. Paint the lighter side of the nose with midvalue blue-violet and midvalue warm red. Next to this, paint midvalue warm pink. Add midvalue blue-violet to the shadow on the lighter side of the nose. Paint the light area down the middle of the nose with light burnt umber and light warm pink. Use midvalue and light gold ochre for the left side of the nose. Paint the bottom of the nose with midvalue warm red and midvalue warm pink. Carefully add the shapes of the nostrils with the darkest red-violet layered with dark reddish brown. Paint the sides of the nostrils with light burnt umber and light warm pink. Add more light gold ochre to the right side of the face. Paint strokes of light burnt sienna to begin to establish the highlights of the face. Add midvalue blue-violet to the shadow on Elijah's left side and underneath the nose.

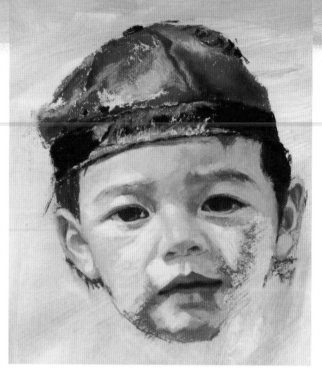

6 Paint the Lower Face

Establish the sides of face. Using the nose-to-chin measurement, determine the distance from the edges of the nose to each side of the face. Next, using the same gauge, determine the distance from each corner of the mouth to the sides of the face. Connecting these placements, lightly draw the sides of the face with midvalue warm pink. Take care in establishing the angles of the lower face as they turn in toward the chin. Paint the shadow under the nose with midvalue blue-violet layered with midvalue warm pink. Paint the bow of the upper lip with the same combination. Using midvalue warm red, paint the lips. Add dark red-violet and dark reddish brown to the darker shadow areas of the lips. Paint the opening with darkest red-violet. Paint the lighter area of the bottom lip with midvalue warm pink. Define the upper lip by painting the skin above it with light burnt sienna. Use midvalue blue-violet and midvalue warm red for the outer corners of the mouth. Paint under the bottom lip with midvalue red-violet. Add dark blue-violet to the bottom of the chin. Paint strokes of midvalue warm red on the lower right edge of the chin. Next to this, paint a lighter warm red followed by light burnt sienna. Blend these areas using midvalue burnt umber.

Meet Challenges With a Fresh Eye

Sometimes, if I get stuck while working on a particular feature, I will leave it and move to another part of the painting for a while. Then, when I come back to the challenging part, I'll be able to look at it with a fresh eye.

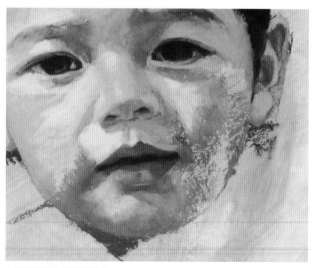

LAYERING CLOSEUP

Lay down the darker strokes of color in an area. Paint the area a bit larger than you will need. Take the next value and hue and make strokes that overlap into the darker ones. Continue with the next and lighter value and/or hue, layering over the midvalue previously painted. If necessary, take a hard pastel of the same hue and value as your midvalue pastel and lightly add strokes to further blend the edges.

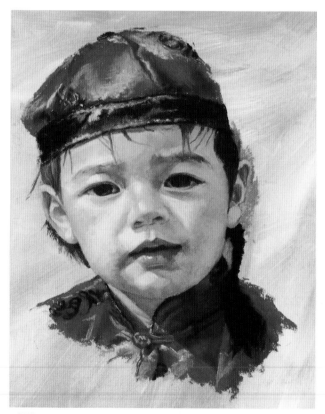

7 Paint Hair on the Forehead

Paint the strands of hair on the forehead with dark brown. Beginning about ¼" (6mm) from the hatband, paint dark reddish brown over the strands. Paint light blue-violet to the right of a few of the strands to help them stand away from the forehead (these are the cast shadows).

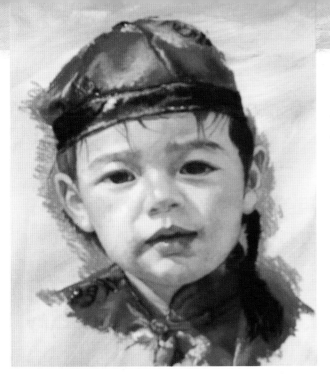

8 Paint the Shirt and Collar

Paint the shadow under the chin and above the collar with dark blue-violet. Layer over the area under the chin with midvalue warm pink. Layer over the area above the collar with reddish brown. Add a light line of midvalue warm red between this shadow and the lighter area of the neck. Paint the lighter area with midvalue burnt umber and midvalue warm pink. Paint the shirt beginning with darkest red-violet for the shadows, followed by dark red-violet, then midvalue cool red. For the edge of the collar, use darkest red-violet. Paint the lightest areas of the trim with light blue-violet. Because the clothes are secondary to the face, just suggest the pattern on the lighter shoulder with darkest red-violet. Paint the highlight areas with lightest cool pink. Paint the yarn braid with the darkest red-violet. Use midvalue red-violet to add a few details.

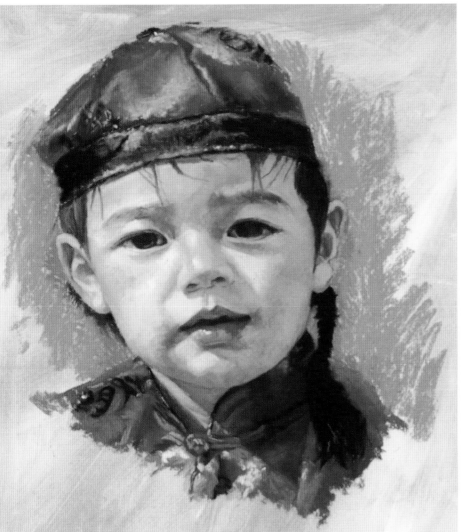

9 Add the Light Accents

Add the light accents using the lightest pink on the lower lip and the lightest burnt sienna on the tip of the nose. Use a midvalue olive green to clean up the outside edges of the hat and head.

ELIJAH
Pastel on Wallis Sanded Pastel Paper
18" × 14" (46cm × 36cm)

Light Skin Tones, Angled Front View

Anna's face and hair are light and she has sparkly blue eyes. These features pose exciting challenges. Fair skin has more subtle changes in value than darker skin, so it can be harder to model the planes of the face. When you paint Anna's lighter hair, you will need to take more care with the separations of her bangs.

REFERENCE PHOTO

MATERIALS

SURFACE
18" × 14" (46cm × 36cm) Wallis Sanded Pastel Paper, toned with mid-value olive green

PASTELS
black-green, blue (light, midvalue and dark), blue-gray (lightest, light and midvalue), blue-green (light), blue-violet (light, midvalue and dark), brown (midvalue), burnt sienna (lightest and light), burnt umber (light, midvalue and dark), cool red (midvalue), gold ochre (dark), pink (lightest), raw umber (light and midvalue), red-violet (light, midvalue and darkest), reddish brown (dark), warm brown (light and midvalue), warm pink (light), warm red (midvalue), yellow ochre (midvalue and dark), optional primary colors for dress

1 Map the Face
Map the face as shown in chapter 3. Notice there aren't any strong shadow areas as we saw in the portraits of Dzifa and Elijah (see pages 60 and 64). With dark blue-violet, lightly lay in the shadow area on Anna's left cheek. Add the shape next to her nose and beside her left eye. Block in the dark on her ear. Now, using the same blue-violet, block in the shape of the dark part of the hair. As you do this, mark areas of directional changes.

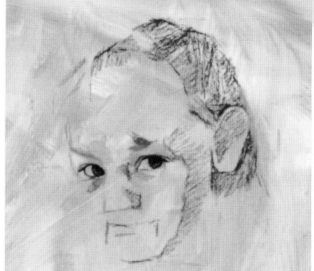

2 Paint the Eyebrows
With a midvalue warm brown, draw in the eyebrows. Paint the area under her right brow with midvalue warm pink. Paint the area from there out to the edge of the face with light burnt umber. Paint the area under her left brow with midvalue warm pink layered with light raw umber. Paint the area to the right of this with midvalue warm pink. Use dark reddish brown to define the upper eyelids. Make the separation between the upper lids and the top of the eyes midvalue blue-violet, glazed with light warm pink. Block in the irises with black-green. Finish forming the shape of the irises with light blue-gray. Paint the areas under the eyes with midvalue blue-violet.

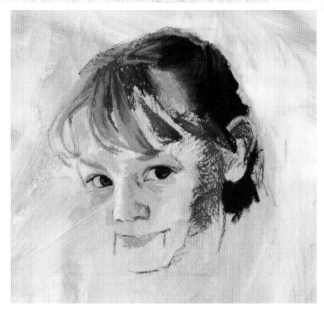

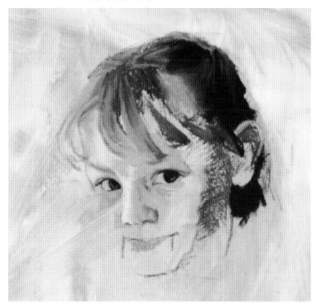

3 Paint the Hair and Nose

With the darkest red-violet, paint the dark areas of the hair. Layer over this with dark burnt umber. Paint the darkest area of the bangs on Anna's right with midvalue red-violet layered with warm brown. Paint the midvalue areas with midvalue warm brown and dark yellow ochre. Use light burnt sienna for the light area. Paint the dark area of the rest of the bangs with darkest red-violet, layered with dark reddish brown. Make the separations with midvalue warm brown. Remember that you don't need to paint every strand or section, just the ones that will give the idea of bangs. Add midvalue warm red and midvalue gold ochre to the warm areas.

Paint the nose using dark blue-violet and midvalue red-violet to establish the near side. Paint the nostrils with dark reddish brown, then midvalue warm red. Paint the near side with midvalue warm red. Lay strokes of light warm pink next to this. The light area to the left side of the nose should be painted with light burnt sienna. Paint over the shadow on the cheek and the inner ear with dark reddish brown. Add midvalue warm pink to the tip of the ear. Add midvalue warm red to the mouth.

4 Paint the Forehead

Paint the forehead under Anna's right bangs using midvalue blue-violet glazed with light warm brown and light warm pink. Paint the edge of the forehead with dark gold ochre and warm brown. Use midvalue gold ochre to blend with the side of the shadow under the bangs.

For the area between the strands of hair on the forehead, use a combination of gold ochre, warm pink and midvalue burnt umber. Add warm red to the corners of the eyes and warm pink under Anna's right eye and next to the near side of the nose.

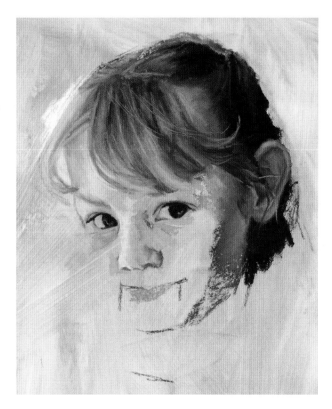

5 Work on the Near Side of the Face

Use light warm brown to carefully draw the strands of hair that cross over and curl up the near side of the head. Paint the ear with dark reddish brown, and with midvalue red-violet in the inner ear. Use midvalue warm red and midvalue warm pink for the lighter areas. Use light red-violet for the inner edge of the ear. Paint midvalue warm red and midvalue red-violet on the shadow on the cheek. Add strokes of midvalue blue-violet and midvalue warm red to the area above her left eye.

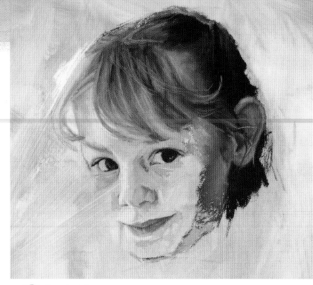

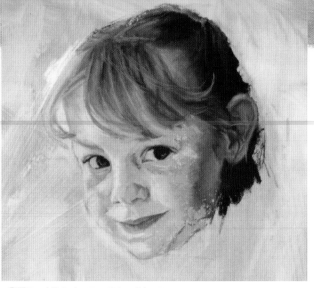

6 Paint the Lips

Using midvalue warm red, paint the lips. Use dark red-violet for the darker area on Anna's upper left side, and lighter warm pink for the lighter areas. Use dark reddish brown for the separation. Paint the mid-line above the lips with midvalue blue-violet and midvalue warm pink. Paint the skin above the far side of the mouth with light burnt sienna. Paint midvalue warm pink into the lower lip on the near side. Add light blue-violet to the cool areas around the mouth and on the area on Anna's lower left side.

7 Establish the Far Side of the Face

Establish the far side of the face. Paint midvalue warm pink on the far side of the nose and mouth. Paint strokes of light burnt umber from the midvalue warm pink toward the outside of the face. Paint strokes of light warm pink above the near side of the mouth. With midvalue warm red, paint strokes on Anna's left cheek. Next to the warm red, paint strokes of midvalue warm pink. On the area from the near side of the nose to the warm pink, paint light burnt sienna. Paint midvalue warm pink on the lower right side of the chin.

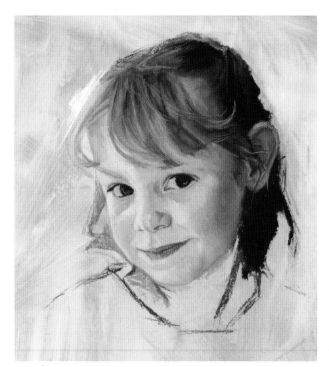

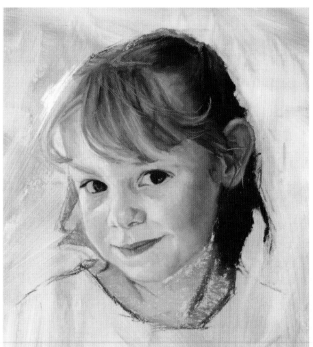

8 Blend Colors Together

Use hard pastel in mid- and light-value burnt umber to start to lightly blend the areas of light color together. Use hard pastel in midvalue brown to gently blend the areas of darker color together. Bring down the dark shape of the hair on Anna's left with the darkest red-violet.

Using midvalue warm brown, draw the shapes of the hair on the far side of the face. Mark the near side of the neck with the dark reddish brown. Mark the placement of the shoulders and edge of the dress.

9 Paint the Jaw and the Neck

Paint a line of dark reddish brown next to neck edge of the dress. Draw the creases in the neck on Anna's right with dark blue-violet. Go over these with reddish brown. You will slowly blend the lower one toward the edge of the dress and the upper one toward the chin. Paint strokes of midvalue warm red and midvalue pink on the far side of the neck. Paint midvalue warm pink in the center. Paint strokes of midvalue blue-violet under the lower left jaw. Use warm brown on the lower left side of the neck. Paint a line of midvalue warm red next to the dark line on the neck.

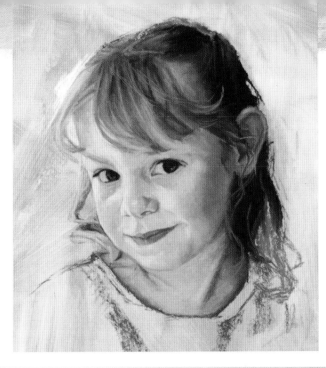

10 Define the Hair

Finish defining the hair on the far side by using dark raw umber and midvalue warm brown to mark the dark shape. Use light warm brown and light raw umber to go over the lighter strands. Add dark yellow ochre to the inner edge of the strands. With midvalue warm brown, draw the shape of the curled section of hair on Anna's left. Using midvalue warm red and midvalue warm pink, blend from the edge of the dress on Anna's right toward the crease. Use midvalue warm pink and midvalue burnt umber to blend the areas of color on the center of the neck together. Use midvalue red-violet and light warm brown to blend the areas on the near side of the neck. Paint the shadow shapes on the dress with midvalue blue.

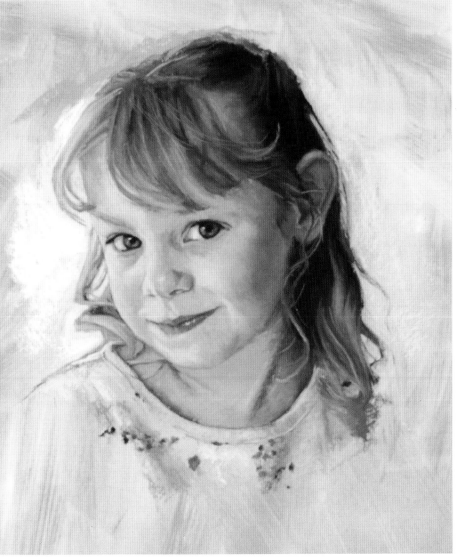

11 Add Finishing Touches

To further define the side of the hair, use the lightest burnt sienna and the lightest blue-gray for the background. Also use this to make negative shapes between the strands on the far side. Use lightest burnt sienna and lightest blue-gray with a bit of light raw umber to work into the hair on the near side. Finish the longest strand on Anna's left by painting dark reddish brown into the dark red-violet under the ear, followed by light warm brown painted into the reddish brown. Finish the details with light warm brown and light raw umber. I decided to leave the details of the eyes till the end. It's like dessert. To finish them, use a midvalue blue around the pupils on the lower edge of the irises. Add a bit of blue-gray to this. For the lighter area of Anna's right eye, use a bit of light raw umber and light warm pink. For the highlight, use the lightest blue-gray. Use the midvalue blue-violet to reestablish the cool area under the near jaw. Use light blue-greens and blues for the dress, adding highlights with lightest blue and lightest pinks. To add a bit of sparkle and interest, add the primary-colored dots for the decoration on her dress.

ANNA
Pastel on Wallis Sanded Pastel Paper
18" × 14" (46cm × 36cm)

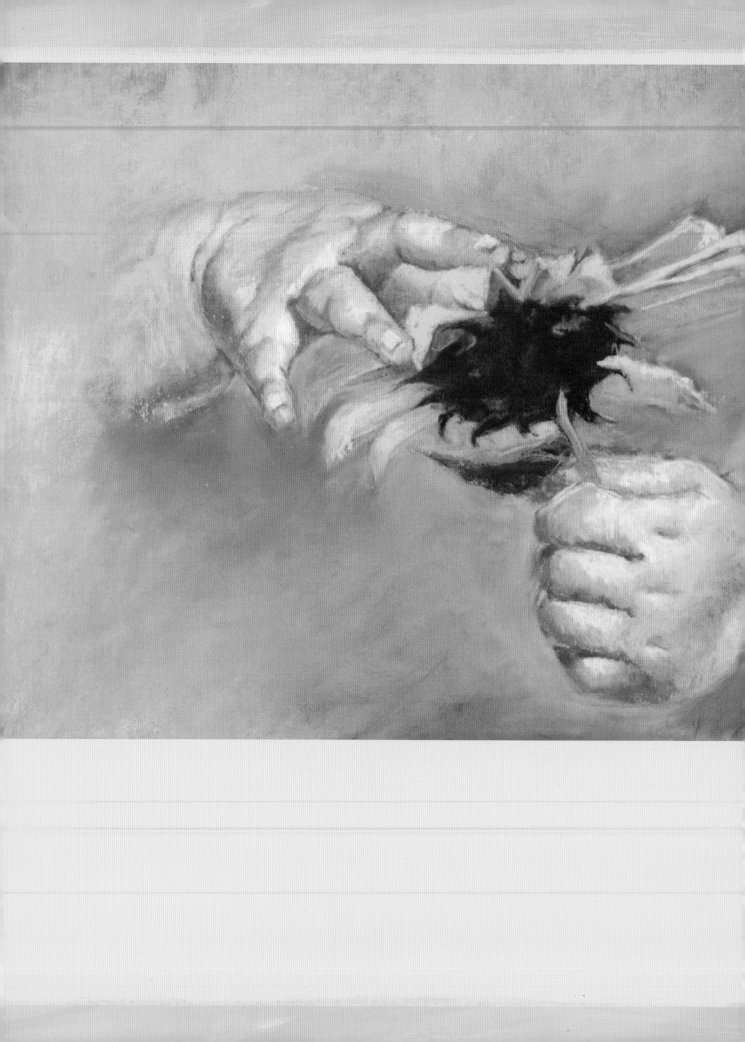

Painting *the* Hands

Our hands tell a lot about us. Many people use them to help express themselves while talking. In a painting, they can enhance your concept and help you tell your story. Visually, the hands and arms can serve as directional tools, moving the viewer's eye around a composition. Thus, it's important to learn to paint hands well, but painting them can inspire fear even in the most confident artist. However, if you approach them as you would the face—as a collection of shapes, values and colors—you will have less to fear.

When photographing your subject, make sure to keep the hands in mind. It is so easy to get caught up in face and body movement that you can forget about the hands. I have learned this the hard way, spending several hours shooting reference photos only to get them developed and find that none of the hand positions are going to work. The face is the first priority of course, but make sure that the hands also have good lighting and are in an interesting position. Try to photograph the hands in two different positions. When working with children, I try to take closeups of the hands. With a digital camera, I can see right away if I need extras. In my experience, children seem less reserved when it comes to just having their hands photographed, and they are usually cooperative when asked to reposition their hands.

SUNFLOWER
Pastel on Wallis Sanded Pastel Paper
8" × 12" (20cm × 30cm)

Focusing on Hands

Hands can enhance your overall concept. Children's hands are rarely still, and they can indicate whether the child is relaxed or nervous. Since most of my work is about children at play, hands have become a crucial point. In fact, I have found hands are so expressive by themselves that I have begun a series of paintings with hands as the focal point. It is amazing to see how beautiful and powerful they can be as a central theme.

CRISP FRUIT, SOFT HANDS

This was a choice apple from my tree. I wanted to paint the ripe, juicy fruit against the child's eager, chubby hands.

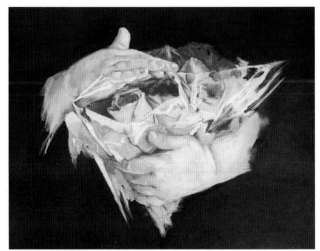

CONTRASTING VALUES

The orange of these roses against the violet cellophane caught my eye. I also was touched by the tender way the child caressed the flowers she was about to give her mother for Mother's Day. I painted the background very dark to bring out the pale hands and bright flowers.

CONTRASTING TEXTURE

This girl was doing what most girls love to do: play dress up. I liked the youthful grace of her ungloved hand. I used a piece of Wallis Sanded Pastel Paper from a batch that was rougher than usual. Rather than send it back, I experimented with it. Notice that the texture is coarser than the more refined finish of the example above. Paper does make a difference.

CONTRASTING TEMPERATURES

I painted this from a reference photo I captured while on a photo shoot with a particularly shy little girl. She really held on to her mother's hand. It made me think of how secure children feel with their parents. I had fun painting the rich, warm shadows and cool lights of the mom's hand, tightly gripped by the little girl's fingers.

Keeping the Hands in Proportion

Determine the size and position of the hands in the same way you determined the proportions of the face. Use the distances between facial features to gauge where the hands should go. Then use measurements such as the width of a wrist or length of the hand as a whole to determine the length and width of the fingers. Start with the largest measurement and move down to the smallest.

Measure Large to Small

It is better to work from large shapes or areas first, then break those down into smaller shapes. If you begin with the smallest measurement such as the width of the eye, you'll get bogged down in details before establishing the overall shape and likeness. Also, the width of the eye makes for a small, cumbersome gauge to mark the distance from the bottom of the subject's chin to the elbow. Instead, use the height of the head for a larger, simpler gauge.

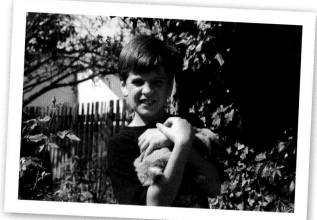

REFERENCE PHOTO

Justin accompanied me on a photo shoot with three two-year-olds and a rabbit. It was his job to help corral the bunny. I shot this picture after we had a hard time capturing the little creature, who managed to squeeze herself through a hole in the fence. The way he is holding the rabbit shows security as well as gentleness.

What drew me to this pose is the way the light falls from the upper left, casting such a beautiful shadow on Justin's right hand and arm. I also like the way the arms cross, giving this composition some direction.

THUMBNAIL SKETCH

A thumbnail of your composition will allow you to tell right away whether the hands are awkward. This is especially important when working from photographs. Sketching will help you answer other compositional questions. Are the hands and arms overpowering the face? Are they directing the viewer around the painting, or outside the composition? Do they contribute to what you are trying to say?

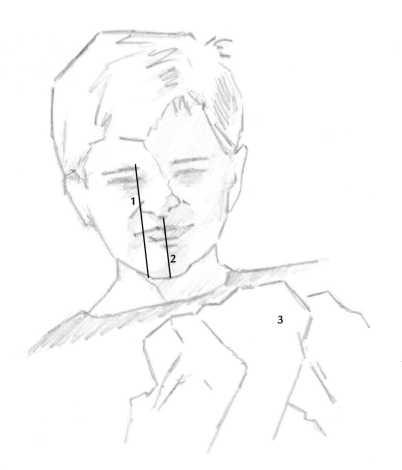

1 Use plumb lines (straight lines) from the eyes along the nose to determine the relationship between the eyes, nose and mouth. This plumb line shows that the side of the nose is slightly to the left of the corner of the eye. It also shows how far over to put the corner of the mouth.

2 Measure from the nose to the chin to determine how long and wide the hands should be. Are they bigger or smaller? Also use this measurement to determine how far from the chin to begin the hands.

3 Keep the hands simple by drawing block shapes showing the general shape and movement.

Sketching Hands

Painting hands can be a challenge, but, with practice, you can learn to paint expressive hands in your portraits. To become more confident in drawing and painting hands, do a few 1- to 5-minute sketches every day of your own hand in different positions.

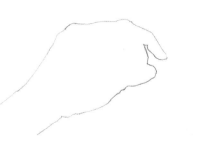

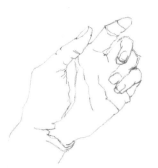

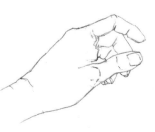

CONTOUR DRAWING

This is a 1- or 2-minute contour drawing. For this kind of drawing, keep your pencil on your paper and draw very slowly. Follow the outside contour of your hand, drawing as you go. I generally begin at the outer wrist, continuing up around the fingers and then back to the lower part of the wrist.

CONTINUOUS CONTOUR DRAWING

This is also a 1- or 2-minute drawing. This time keep your pencil on the paper and draw the hand using one continuous line. To form the inside details, draw inward and then retrace your lines keeping the pencil down the entire time.

DETAILED DRAWING

This drawing took about 4 minutes. For this more conventional drawing, use more sketching lines. For all of these quick drawings, try to avoid using an eraser. If you don't like a line, redraw it, leaving the first one. These sketches allow you to practice drawing skills as you prepare your mind for painting.

PRELIMINARY SKETCH

This is the preliminary sketch for the demo on pages 77–80. The format is a 12" (30cm) square. I divided the paper into thirds both horizontally and vertically, then positioned the focal point (the right thumb resting on the left hand) where the divisions intersect on the upper left. The rabbit is close to the upper-right intersection. This is an easy way to determine where to place your subject according to the golden mean, especially when the subject is simple or a single object. I've used this format in most of the hand demonstrations in this chapter. Because the Cupped Hand (page 84) has just one main subject, I positioned it a little off center.

Handy Tips

- Paint hands with colors that are a bit cooler than the tones of the face to keep them secondary.
- Include some of the tones from the face on the hands to unify the painting.
- Keep hands simple by focusing on their basic shapes and directions rather than on every line and crease.

Grasping Hands

For this demo, I focused on Justin's hands and arms. The rabbit adds a nice texture that contrasts with the smoothness of the skin. I liked the pattern of light and shadow and the secure look of the rabbit.

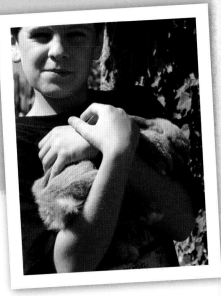

REFERENCE PHOTO

MATERIALS

SURFACE
12" × 12" (30cm × 30cm) Wallis Sanded Pastel Paper, toned with mid-value olive green

PASTELS
blue-gray (light and midvalue), blue-violet (light, midvalue and dark), brown (midvalue), burnt sienna (lightest), burnt umber (light and midvalue), olive green (midvalue), red-violet (midvalue, dark and darkest), reddish brown (dark), warm brown (light), warm pink (light and midvalue), warm red (midvalue), yellow-green (light)

BRUSHES
small, soft fan brush

1 Mark the Position of the Right Hand
The right hand is the focal point, so start by marking its position with dark blue-violet NuPastel. This will look like a box as you mark the top, bottom and sides. The right hand is one-third as high (vertically) as it is wide (horizontally). Next, mark the edge of the left hand using the height of the right hand as the gauge. Measure from the tip of the thumb out to the left edge of the surface. Determine the shape of the thumb, right index finger and shadow areas on the right hand.

2 Establish Value and Color Shapes in the Right Hand
Paint the fingers inside the right hand with dark reddish brown and midvalue warm red. Establish the shapes of the differing values and colors on the right hand by painting the shadow with midvalue blue-violet and the next shape over with light warm pink. Next to this, paint midvalue warm red. Paint the large light area of the hand with light burnt umber. Add a bit of midvalue warm red to the lower area of the thumb. At this point, these areas remain separate; they'll be blended together with other colors later.

77

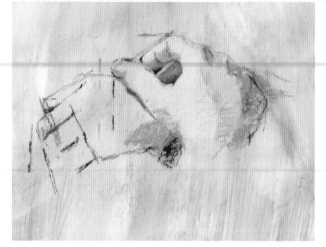

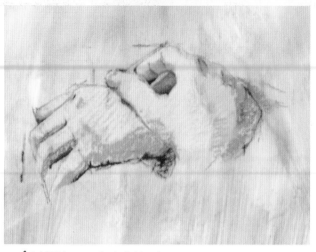

3 Block In the Left Hand
Add dark blue-violet to the shadow at the bottom between the two hands. Above this, paint the area with midvalue red-violet. Mark the fingers on the left hand. Use the height of the right hand to determine the width of each finger. Use your paintbrush to carefully determine the slant of each finger. Add some dark reddish brown layered with midvalue warm red under the thumb. This will make the thumb appear to be standing away from the hand.

4 Add Values to the Left Hand
Bring the midvalue red-violet down the lower edge of the left hand. Paint the shadow edges of the finger with midvalue warm red. Paint the large light area with light burnt umber. Keep all of your strokes light and directional. Add some midvalue warm red where the knuckles will be.

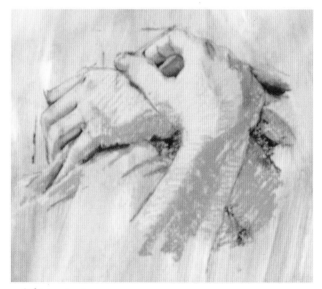

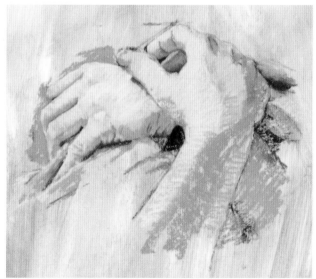

5 Paint the Arms
Use the height of the right hand to determine the width of the wrist and arms. Paint the shadow down the center of the right arm with midvalue blue-violet. Paint strokes of midvalue warm pink on the outer arm. Use midvalue warm red to paint strokes of color on the inner edge of the shadow of the arm. Paint the lightest area of the inner right arm with the light burnt umber. Begin to paint the rabbit where it meets the hands and arms using dark blue-violet. Paint the dark area of the rabbit under the left hand with dark blue-violet, glazed over with dark reddish brown. Begin painting the left arm with strokes of midvalue blue-violet for the shadow. Add midvalue warm red to the outer edge and midvalue warm pink to the inner part of the arm.

6 Add Details to the Hands
Paint some light yellow-green on the outside of the left hand to help define the shape. Use dark red-violet to apply a few well-placed creases on the lower edge of the left hand and little finger. As with everything, "a little dab will do ya."

Paint the knuckle on the little finger in the same way, but start with midvalue warm pink. Use lighter tones as you move away from the crease. Continue working the fingers on the left hand by painting strokes of midvalue warm pink from the shadows out. Add another layer of light burnt umber. Paint light warm pink from the knuckles of the left hand out into the light.

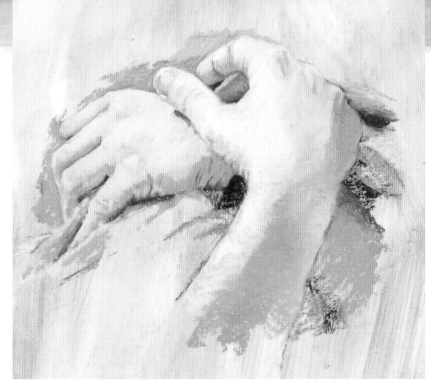

Painting Creases

To paint believable creases, begin by marking the darkest value. For the creases on the lower part of Justin's left hand, use dark red-violet. Lightly paint back into this with midvalue warm red, followed by midvalue warm pink. Then blend back in from the light area with a bit of the lightest tone in the area. In this case, blend with light burnt umber.

7 Paint the Thumbnail

Paint the thumbnail on the right hand by laying down midvalue warm pink in the darkest area. Next, paint into the warm pink with light burnt umber. Paint the creases on the knuckle of the thumb. Use light and midvalue burnt umber to lightly blend the colors together on the right hand. Use a midvalue brown to lightly blend the areas of shadow.

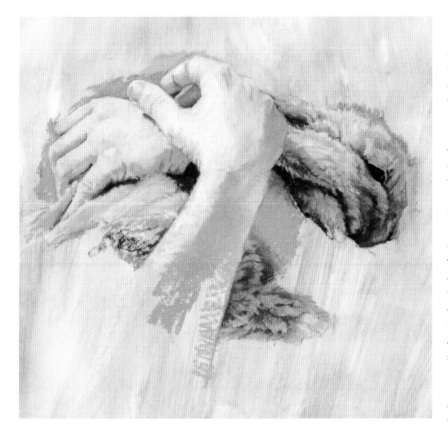

8 Begin the Rabbit

Paint the rabbit, beginning with the darkest part of each area (see page 96 for more on painting fur). Begin with the darkest red-violet in the shadow areas. For the darkest areas of the face, use midvalue blue-violet and midvalue blue-gray. For the lighter and warmer areas of the rabbit's cheek and top of the head, paint strokes of light and midvalue burnt umber. Add to this a few strokes of light red-violet, midvalue warm pink and light warm brown. For the lightest highlights, use the lightest blue-gray. Paint the rabbit's eye with the darkest red-violet. The back of the rabbit is warmer, so use strokes of light warm brown and midvalue and light burnt umber. Add a few strokes of light cool pink. Use midvalue olive green on the outside of the rabbit's head to help define it and to avoid creating a cut-and-paste effect when you add short strokes for the fur.

Continue working down the right arm, using midvalue blue-violet for the shadow and warm red for the midvalue area. Combine the areas of color on the left arm by painting strokes of midvalue red-violet into the dark blue-violet. Use light strokes of midvalue burnt umber to blend the mid-value areas of the left arm.

9 Continue Painting the Rabbit and the Left Arm

Paint the rabbit's back and tail. Paint the shadow under the tail with strokes of midvalue blue-violet, glazed with midvalue warm pink. For the area right under the tail, paint a bit of reddish brown and midvalue warm brown. Use light burnt umber for the light area below the shadow on the left arm. Use a combination of midvalue burnt umber, warm red and midvalue warm pink, lightly layered back and forth, to finish the arm. Define the position of the left rear leg of the rabbit.

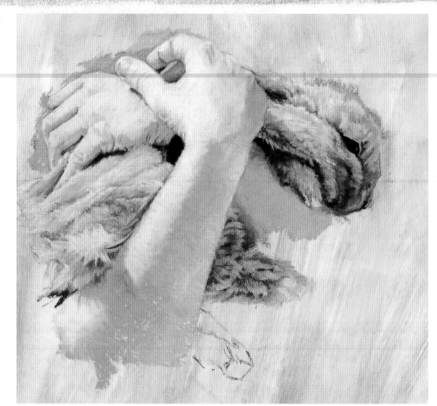

10 Add Finishing Details

Finish painting the rabbit. I felt that the fur below the hands was too warm, competing with the warm flesh tones, so I painted over it with a few light strokes of light blue-gray. The left arm also appeared too warm in tone, so I glazed over this with midvalue olive green.

SECURE BUNDLE
Pastel on Wallis Sanded Pastel Paper
12" × 12" (30cm × 30cm)

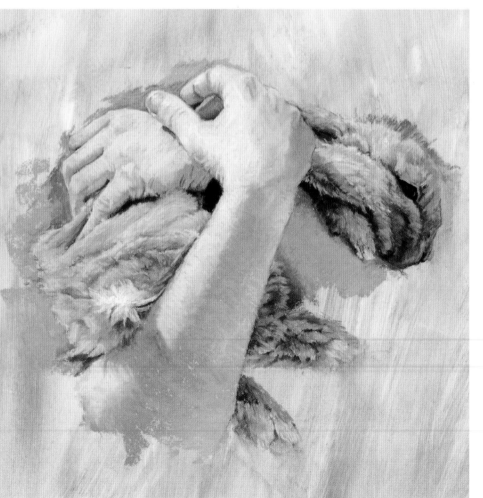

Baby Hands

Babies have such wonderful little chubby hands and fingers. Here, Elisabeth and her mother demonstrate a universal bond: the baby's trusting dependence on her mother and the mother's gentle devotion to her child. The little bracelet adds a bit of interest. The focal point is in the upper-left corner in this composition, following the golden mean.

REFERENCE PHOTO

MATERIALS

SURFACE
12" × 12" (30cm × 30cm) Wallis Sanded Pastel Paper, toned with mid-value olive green

PASTELS
blue (midvalue), blue-violet (light, mid-value and dark), bright orange (light), bright red, burnt umber (light and midvalue), olive green (midvalue), raw sienna (lightest), raw umber (light and midvalue), red-violet (light, midvalue, dark and darkest), reddish brown (dark), warm brown (midvalue), warm pink (light, midvalue and dark), warm red (light and midvalue)

BRUSHES
small, soft fan brush

1 Determine the Hand Position
Map out the position of baby Elisabeth's hand. Measure from the top edge of the curled finger to the inside of the bracelet. The hand is two-thirds as long as it is wide. The distance from where the index finger touches the mother's hand to the bottom of the baby's thumb is a bit more than one-half the distance between the top of the baby's hand to the bottom of her thumb. Use this measurement to determine the length of the index finger. Use this gauge to determine the length and width of other elements in the composition.

2 Define the Fingers
Define the fingers with dark reddish brown. Paint the shadow areas of these fingers with midvalue warm red.

Painting Fingernails

Avoid drawing in the fingernails. Paint the basic color and value, then define only a few boundaries. Create edges on two or three sides, then leave the rest to blend away either into the background or into the finger. This will help to make the fingernails look natural rather than artificial.

 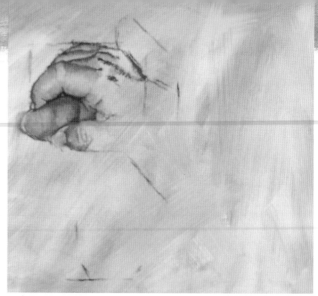

3 Continue to Define Fingers
Continue to define the fingers with brown. Add midvalue burnt umber and midvalue warm pink to the center of the fingers, making vertical strokes to model the rounded form.

Gradating Creases

Notice which side of the crease is the lightest. You'll need to gradate toward the other side.

4 Flesh Out the Fingers
Paint the dark area of the mother's index finger with dark red-violet and dark reddish brown. Paint warm red next to this, followed by midvalue warm pink and midvalue burnt umber. Paint the crease of the mother's index finger with dark red-violet, followed by dark reddish brown and warm red, gradating out toward the tip of the index finger. Establish the creases for the rest of the index finger using dark reddish brown, warm red and midvalue warm pink.

Using dark violet and dark reddish brown, paint the area under the thumbnail on the baby's thumb. Paint out from this with warm red. Paint warm pink on the nail. Paint the light area with light burnt umber. Define the nail of the baby's index finger with dark red-violet and warm red. Paint the bit of nail with midvalue raw umber. Suggest the mother's thumbnail using light and midvalue raw umber.

Mark the area of the knuckle on the baby's thumb with midvalue warm red. Mark the light area with light burnt umber. Paint the area above this with midvalue warm pink. Paint the folds of the inner hand with dark red-violet, midvalue red and midvalue warm pink. Mark the area of the dimple and upper knuckles on the top of the hand with dark reddish brown.

5 Finish the Mother's Thumb and Paint the Baby's Hand and Bracelet
Use warm red and warm pink to paint the area away from the dimple. Paint the area on top of the dimple with light burnt umber and light warm pink. Paint under the knuckle lines with warm red, then midvalue warm pink. Paint the mother's thumb, beginning with midvalue warm red. Paint the area in the center of the thumb with midvalue warm pink. Paint the light area with small strokes of light burnt umber. Add a stroke of light blue-violet on the top outer edge of the thumb. Draw a few lines on the thumb with dark red-violet. Continue the top of the baby's hand with dark red-violet, blended lightly with midvalue warm brown. Paint the small shadow area below the thumb with light blue-violet. Paint the creases of the wrist with dark red-violet. Use dark red-violet and dark reddish brown to draw the beads of the bracelet. Paint the beads at the top of the hand with midvalue red-violet. Paint the others with midvalue raw umber, followed by light raw umber and lightest raw sienna. Paint the diamond-shaped bead with bright red. Add more dark reddish brown to further define the insides of these beads. Add more warm red to the upper part of the hand. Add midvalue warm pink to the lower part of the hand and the skin of the wrist above the beads.

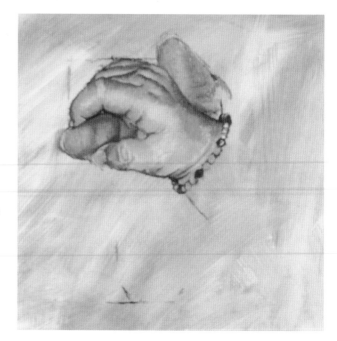

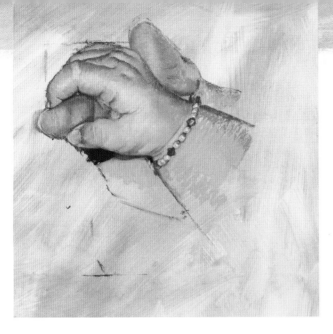

6 **Paint the Baby's Arm and Add Details to the Hands**
Paint the joint of the mother's thumb with dark red-violet and dark reddish brown. Paint into this with strokes of warm red. Add midvalue warm pink to the outer knuckle. Define the outer and lower lines of the arm with dark blue-violet and dark reddish brown. Paint the shadow area under the arm with light blue-violet. Paint the outer edge with reddish brown and warm red. Paint strokes of midvalue warm pink next to the red, with midvalue burnt umber in the middle. Paint more midvalue warm pink above the shadow area. Begin painting the mother's fingers with darkest red-violet, followed by dark blue-violet. Paint the shadow under the baby's thumb with dark reddish brown and midvalue warm red. Add a bit of lighter warm red to the center of the shadow to show light reflecting. Continue painting the mother's finger under the thumb with midvalue warm red and midvalue warm pink. Use a little midvalue burnt umber to blend colors together on the baby's hand. Add highlights on the beads with lightest raw sienna. Add highlights of light bright orange to the red beads.

7 **Add Finishing Touches**
Paint the back part of the mother's fingers with dark red-violet, midvalue red-violet and warm red. Add a bit of light blue-violet to the cool areas. Paint a small amount of midvalue warm pink on the knuckle of the lowest finger. Blend these tones lightly with midvalue warm brown. Paint the edges of the knuckles with midvalue warm pink. Paint the separation of the fingers with dark red-violet. Add midvalue red-violet to the tips where the fingers are in shadow. Because the mother's fingers are less important to the composition, paint them with loose, downward strokes. Suggest the lines of the knuckles with midvalue warm red. Paint the rest of the fingers with midvalue burnt umber. Use light burnt umber for the highlights. If it appears that the mother's thumb is too red or warm in tone, glaze lightly over it with midvalue olive green. Add some midvalue blue to the background to make the hands stand out better.

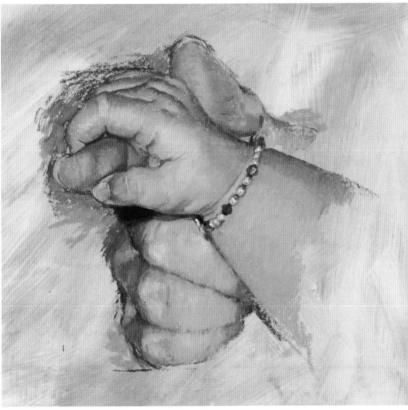

NEW BRACELET
Pastel on Wallis Sanded Pastel Paper
12" × 12" (30cm × 30cm)

Create Natural-Looking Fingers

A key to making fingers look natural is to paint the strokes of the midvalue hue used in the fingers across the darker separation lines of each finger. Do this after the fingers are established.

Cupped Hand

When I asked this model, TJ, what he liked to do, he told me he liked to read. I was surprised that an eight-year-old's favorite activity was reading. I didn't think reading would work for what I was after, so I asked him what else he liked. With a grin, he brought out his metal box of marbles. This photo was taken while TJ and his cat played marbles.

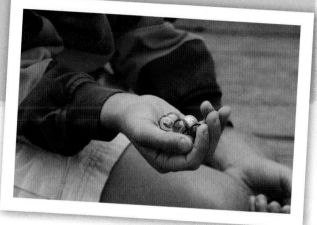

REFERENCE
PHOTO

MATERIALS

SURFACE
12" × 12" (30cm × 30cm) Wallis Sanded Pastel Paper, toned with mid-value olive green

PASTELS
blue-gray (light), blue-green (light, mid-value and dark), blue-violet (light and dark), bright red (midvalue), brown (dark), burnt umber (light and mid-value), cool brown (midvalue), gold ochre (midvalue), green (midvalue), olive green (light and midvalue), raw sienna (lightest), red-violet (midvalue, dark and darkest), reddish brown (midvalue and dark), ultramarine blue (dark), warm brown (midvalue), warm pink (light and midvalue), warm red (midvalue), yellow (light), yellow ochre (light and midvalue)

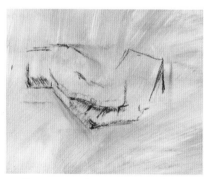

1 Determine the Position of the Hand
With dark blue-violet, mark the basic placement and shape of the hand. TJ's hand is about one and one-third as long as it is high. The width of the wrist is a little less than one-half the height of the hand. Mark the thumb. Its width is about one-half the width of the wrist. Measure the distance between the thumb's knuckle out to its tip. Use this length as the gauge for the rest of the mapping process. Lightly add dark violet to the shadow areas of the wrist, thumb, and the lower part of the hand.

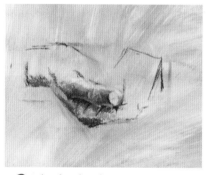

2 Paint the Thumb
Begin by painting the thumb. Paint the lower part with dark red-violet and midvalue cool brown. Paint the shadow under the thumb with dark red-violet and dark reddish brown. Paint the section in the center of the shadow with midvalue warm pink to show where the light is reflecting through. Paint warm red above the red-violet on the thumb. Paint midvalue gold ochre in the center of the lower edge of the hand (above the shadow). Paint lightest raw sienna on the top of the thumb to establish that edge. Paint the tip with warm red. Using darkest red-violet, draw the lines for the creases under the thumb.

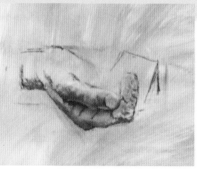

3 Add Detail to Creases, Fingers
Add reddish brown to the creases of the hand under the thumb. Paint the layers of the index finger with dark red-violet, midvalue warm red and midvalue warm pink. Mark the upper edge of the thumbnail with dark red-violet. Establish the lower edge of the nail with dark reddish brown. Begin moving the colors together by painting them back and forth into each other. Add a few strokes of midvalue blue-violet to the lower hand and finger.

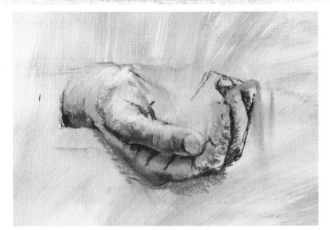

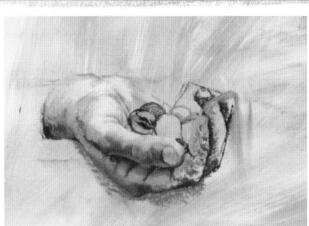

4 Establish the Other Fingers

Using the dark reddish brown and dark red-violet, establish the other fingers. Add warm pink to the tips and a dab of warm red to the fingers. Model the curve of the wrist by painting strokes of reddish brown and midvalue warm red into the shadow. Paint midvalue warm pink up toward the top of the wrist. Paint light burnt umber into this. Add a stroke or two of lightest raw sienna to begin the lightest area. Blend the light of the thumb into the midvalue with light warm pink and light burnt umber. Add midvalue warm pink and dark reddish brown to the creases of the palm. Add a little olive green to the background under the lower edge of the hand.

5 Begin Painting the Marbles

Paint the brown and yellow marble first using dark brown, midvalue yellow ochre, dark reddish brown and light yellow. This will help to define the palm. Paint bright red where the red marble will be. Draw in the darker marbles, paying attention to where they fit in the hand. These will help to establish the fingers. Use light yellow ochre to paint the outer edge of the yellow marble. Add a bit of reddish brown to the crease. Paint into this with a little warm red. Paint back into this with midvalue warm pink. Add lightest raw sienna to the palm and thumb.

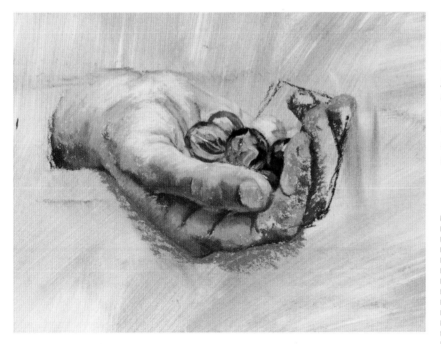

6 Finish the Marbles

Finish painting the marbles. Begin the largest dark marble with darkest red-violet. Layer this where needed with dark blue-green. Add midvalue green in the center along with yellow and yellow ochre in the swirl. Paint the rest of the marbles in the same way, carefully observing their value and shape changes. Glaze over the reflected areas with light blue-gray.

Focus on One Small Area

If you are having trouble determining the color and value of your subject, punch a hole in a piece of paper with a hole punch. Place the hole over the area you want to examine. What color and what value do you see? Move the hole over a nearby area. What color and value do you see there? Breaking large areas down into smaller pieces will help you make color and value decisions.

7 Add Warm Tones

Paint strokes of light gold ochre on the outer palm area. Add midvalue warm red to the fingers. Paint the tips of the fingers with light warm pink and light burnt umber. Establish the dark area of the nail on the index finger with dark reddish brown. Paint the nail midvalue warm pink. With dark reddish brown, draw a broken line to define the edges of the thumbnail. Paint the upper edge of the thumbnail with light burnt umber.

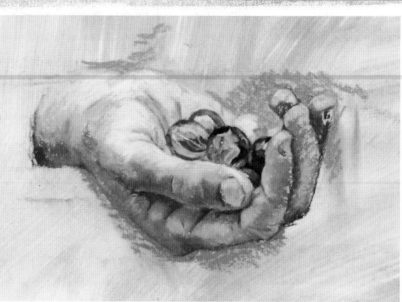

8 Finishing Touches

With dark red-violet, add sides to the rest of the fingernails. Paint a bit of light blue-violet under the nails. Paint the nails with midvalue warm pink. Add a bit of light blue-violet to the lower part of the index nail. Add lightest raw sienna to the lightest area of the nail on the little finger. Paint a bit of lightest raw sienna on the tips of the fingers. Soften the creases in the heel of the hand with light warm pink. Use darkest red-violet for the shadow under the cuff. Add a bit of midvalue blue-violet to the shadow on the wrist. Add dark blue-green and light blue-green on the cuff to help define the fold. Paint light olive green and midvalue green to the background.

Background Advice

Paint the areas behind the light areas of your subject with a darker value. Paint the areas behind the dark areas with a lighter value. This will enable the subject to come forward and take center stage.

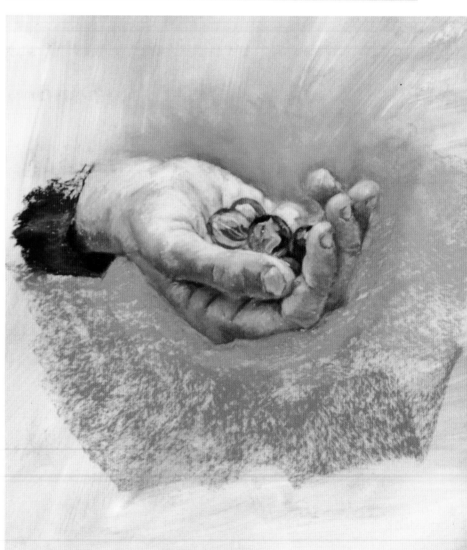

Graceful Hands

Nazrawit appeared nervous during a photo shoot with her brother, so she kept her fingers busy. I chose this shot because I like the graceful position of her fingers and the way the cool teacup contrasts with her warm brown skin. I gave myself a little more structure to work from in this composition by beginning with a more careful drawing, but will still work from one area out. I am not tied to the drawing and will probably need to correct as I go. I always have the freedom to change.

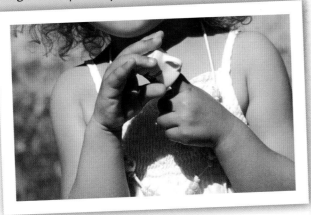

PHOTO REFERENCE

MATERIALS

SURFACE
12" × 12" (30cm × 30cm) Wallis Sanded Pastel Paper, toned with mid-value olive green

PASTELS
blue (light and midvalue), blue-gray (lightest and light), blue-violet (dark), burnt umber (light and midvalue), raw sienna (light), red-violet (lightest, light and dark), reddish brown (dark), warm brown (light and midvalue), warm pink (light and midvalue), warm red (midvalue), yellow-green (light)

BRUSHES
small, soft fan brush

1 **Map In the Basic Shape of the Hands**
Map in the basic shape of the hands with dark blue-violet. The height of Nazrawit's right hand is just slightly less than three times the width of the wrist. Use this measurement to determine the length and position of the little finger. It is about as long as the wrist is wide. Use the width of the wrist to determine the width of the little finger.

2 **Draw the Fingers and Paint the Shadows**
With dark blue-violet, draw in the fingers. Use your paintbrush to determine angles. Use the width of the little finger to gauge the width of the other fingers. Block in the shadow of the palm with dark blue-violet.

Paint the shadow area of the little finger with dark red-violet. Paint next to this with midvalue warm red. Then add midvalue warm pink. Mark the creases of the knuckle with dark reddish brown. Paint the outline of the negative space between the hands with midvalue warm pink. Paint a line of light raw sienna above the little finger. Add midvalue warm red to the middle two fingers.

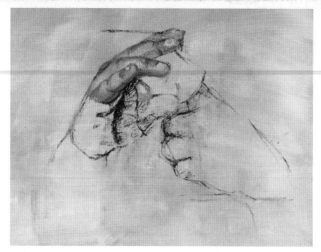

3 Paint the Other Fingers

Paint the other fingers with dark red-violet for the darkest areas and the creases. Use warm red and warm pink for the midvalue areas. Paint the nails with midvalue warm pink.

4 Blend Colors and Define Edges

Blend the colors of the fingers together with midvalue burnt umber. Add lightest raw sienna to the nails. Define the bottom edges of the nails with dark reddish brown. Paint dark reddish brown and dark red-violet into the shadow under the little finger. Paint the shadow on the teacup with dark blue-violet and midvalue red-violet. Add the lightest blue-gray above the ring finger of Nazrawit's right hand to establish the edge of the tea cup. Add a touch of light blue-gray under the second finger.

5 Develop the Shadow

Continue developing the shadow of the right hand by painting dark red-violet and dark reddish brown over the dark blue-violet already established. Paint some midvalue warm red around the edges of the thumb. Paint midvalue warm pink in the middle of the thumb. Add strokes of midvalue warm brown on the outer edge of the hand. Mark the dimple with dark blue-violet, layered with dark red-violet. Add strokes of midvalue warm pink along the jagged edge of the shadow of the palm. Gradate dark blue-violet, dark reddish brown, midvalue warm red and midvalue warm pink at the bottom of the hand, above the wrist. Add midvalue blue-violet to the shadow on the teacup. Use reddish brown for the crease of the wrist. Paint the cast shadow under this crease with dark red-violet and dark reddish brown.

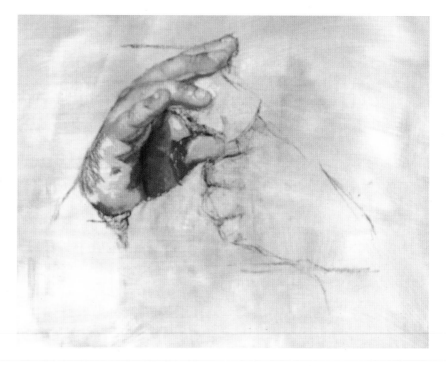

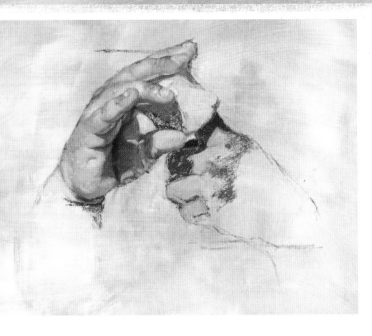

6 Refine the Values

Paint under the dimple with light burnt umber. Add midvalue warm red and midvalue warm pink above the dimple. Start blending the tones of the palm with midvalue burnt umber. Paint the crease with midvalue warm red. Paint the outer wrist with light burnt umber. Lighten the outer edge of the jagged shadow with midvalue warm red. Add midvalue warm red to the edge of the shadow of the thumb. Paint the light on the palm with light warm pink. Paint the shadow on Nazrawit's left hand with dark blue-violet layered with dark red-violet. Add midvalue warm pink and midvalue burnt umber to the left fingers. Paint strokes of midvalue warm brown and midvalue warm red on the knuckles of her left hand. Paint over the shadow on the teacup with midvalue blue. Add light burnt umber to the thumb.

7 Paint the Shadow on the Left Hand and Add Finishing Touches

With dark blue-violet, paint the shadow on the lower edge of the left hand. Glaze over the shadow with midvalue warm red. Paint across Nazrawit's left hand with midvalue warm pink and midvalue burnt umber. Paint the light areas next to the shadow with light raw sienna. Add dabs of lightest raw sienna for the knuckles. Place a line of light red-violet along the lower edge of her left hand. Draw in the creases of the wrist with dark red-violet.

Blend the colors on Nazrawit's right hand further with light warm brown. Paint down the arms with midvalue burnt umber, blended with light warm brown. Paint the shadow of the teacup with midvalue blue-violet and light red-violet. Add dark red-violet above the thumb. Paint the rest of the teacup with lightest blue-gray. Paint the fabric under the hands with dark blue-violet, layered with midvalue and light red-violet. Add light blue for a few accents.

MINI TEACUP
Pastel on Wallis Sanded Pastel Paper
12" × 12" (30cm × 30cm)

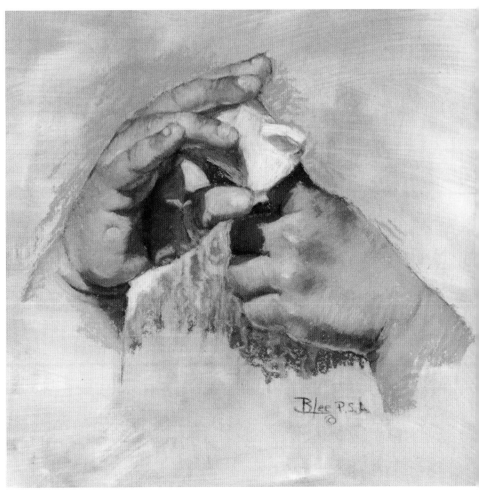

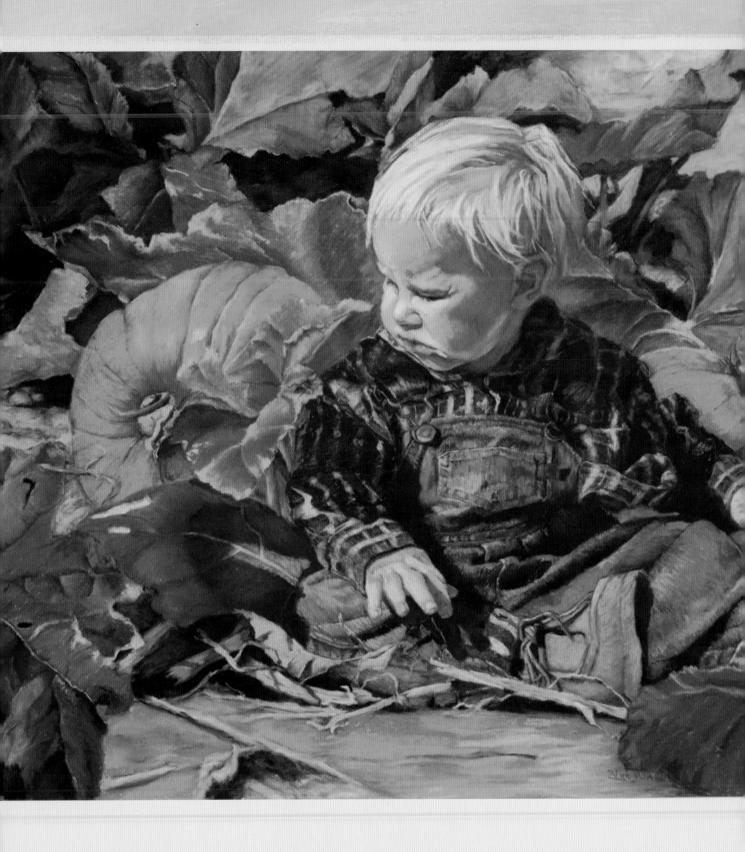

Fabric *and* Clothing

You've painted the face, so now what? How do you make clothing look like clothing? This is one of the most commonly asked questions. Included in this chapter are seven demonstrations showing how to portray the main types of fabric or clothing I encounter in my work, painting everything from ballerinas to cowboys. Clothing should play a supporting role, so it should be handled with less detail than the face. If your composition is very tightly rendered, you can add more detail to the clothing. If your painting style is looser, the clothing may be painted more broadly. As with painting the face, rendering fabric requires careful observation of shapes, values and colors. I use a lighter stroke when painting clothing and usually let more of the surface peek through.

SQUASH BUG
Pastel on Wallis Sanded Pastel Paper
18" × 24" (46cm × 61cm)

Tulle

Most little girls love fancy things, so you will find ample opportunity to paint tulle in ballet and other costumes. For this demo, I chose to tone the surface with midvalue raw umber; it is a bit browner than olive green, so it will provide better contrast to the blue ballet skirt.

REFERENCE PHOTO

MATERIALS

SURFACE
8" × 8" (20cm × 20cm) Wallis Sanded Pastel Paper, toned with midvalue raw umber

PASTELS
blue (lightest, light, midvalue and darkest), blue-green (lightest, light, midvalue and dark), blue-violet (midvalue and dark), green (light and midvalue), red-violet (light), warm brown (light and midvalue)

1 Mark the Position
Using dark blue-violet, mark the position of the skirt on the left side of the composition. Begin with the large fold that overlaps the bodice. This will be the focal point.

2 Establish the Darkest Area
Paint dark blue-green abstract shapes to begin defining the folds near the focal point. Take the darkest blue and paint the part of the bodice directly above this. This will help establish the darkest part of the composition. Continue working shapes next to the dark ones using midvalue blue-green and midvalue and light blue.

Paint Abstract Shapes, Not Objects

Working folds in any fabric becomes an exercise in seeing abstract shapes in varying colors and degrees of value. Don't think in terms of painting a tutu; think in terms of shapes and how they meet other shapes. An exercise such as this requires patience as well as good concentration skills. It can be therapeutic. I have found that I need to warm up by doing 1–2 minute contour drawings before I can concentrate well enough to paint most types of fabric—or at least the ones with folds or patterns.

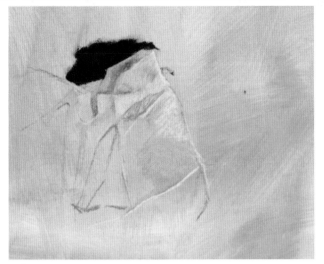

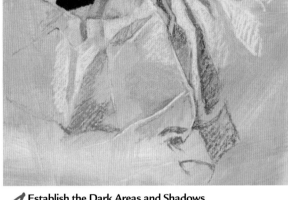

3 Define the Main Fold

Work your way down the skirt, marking sections and shapes. Use midvalue blue for the large area on the middle of the main fold. Use light blue to establish the edge of this fold. Notice how the edges of the folds are usually lighter in value since they catch the light. Tulle is translucent, so keep your strokes light, leaving room to let the surface show.

4 Establish the Dark Areas and Shadows

Work to the right of the focal point using dark blue-green to establish the dark areas of the folds. Add light warm brown to the places where the floor is showing through. Paint the lighter shapes with light blue and light blue-green. Add a few different colors such as midvalue blue-green, light green, light blue and light red-violet to the shapes as you see them. Put strokes of midvalue blue and midvalue green side by side in the darker shapes. Add a few strokes of light warm brown. Work the shapes to the left of the focal point the same way. Add some midvalue blue-violet to the shadow areas.

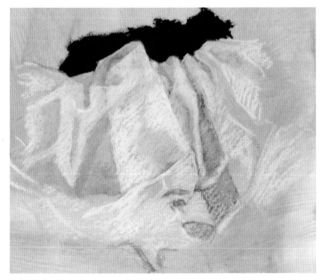

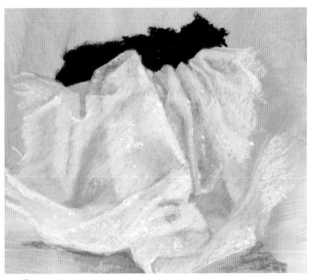

5 Continue Defining the Folds

Work down the skirt by painting the dark shapes with dark and midvalue blue-greens. Add light blue and light blue-green to the light shapes. Paint strokes of light warm brown where the floor shows through. This will be more evident closer to the floor. Keep in mind that the folds of tulle underneath will also show through. Take care to make sure the folds underneath line up where they begin, end and begin again as they are broken up by the outer fabric. Turn your surface upside down before painting the darkest blue of the bodice above the right side of the skirt. This will keep the dark blue from sifting down onto the lighter areas. Add a bit of midvalue warm brown to the floor below the skirt.

6 Add Sparkles and Finishing Touches

Beginning at the focal point, use light blue and light blue-green to blend the shapes together and soften the edges. Keep these strokes light. Using a slanted stroke will give the fabric motion. Soften dark edges with a midvalue of the same color. Start at the edge of the dark shape and stroke outward; this will soften and lighten simultaneously.

Reestablish edges that are important to the flow of the skirt. Use the lightest blue to add the sparkles. Paint these sparingly, just touching the surface with the end of the pastel and pulling away. Adding a few in the areas that catch the most light will be more effective than painting them all over the skirt.

Satin

When painting shiny fabrics and any fabric with folds, focus on the three main values and the rest of the values will fall in line.

Green is not my favorite color. When I stand before a display of pastels, greens generally don't grab my attention, begging me to buy them; thus, I don't have many greens. Fortunately, green is a secondary color, so I can use blues and yellows to create other tones. I toned the surface with raw umber instead of olive green to make the green fabric stand out.

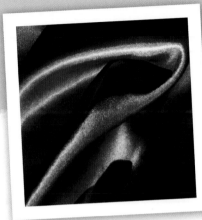

REFERENCE
PHOTO

MATERIALS

SURFACE
8" × 8" (20cm × 20cm) Wallis Sanded Pastel Paper, toned with midvalue raw umber

PASTELS
blue (lightest, light, dark and darkest), blue-green (light), blue-violet (dark), green (light, midvalue, dark and darkest), olive green (dark), red-violet (darkest), ultramarine blue (midvalue), warm green (lightest, light and midvalue), warm yellow (light and midvalue)

Blend With Strokes, Not Fingers

To blend tightly woven fabrics, make strokes in a crosshatch pattern. Avoid the temptation to blend with your fingers. The fabric may be smooth, but it will have more life and energy if you let your strokes do the blending.

1 Draw the Major Folds
Use dark blue-violet to draw the major folds. Next, use the same color to lightly block in the darker values. Paint the darkest area in the center with darkest red-violet. Glaze over this with darkest blue. Paint into this with dark olive green. Create a transition between values in the center by blending with a hard dark green pastel.

2 Paint the Dark and Midvalues of the Main Fold
Add light green to the outer edge of the centerfold. Blend with a midvalue green. Use a harder midvalue green to glaze over the light green, taking it into the darker green. For the left edge, bring small strokes toward the center with a hard midvalue green. Begin the large fold above the center by painting a dark blue line from left to right at the top of the fold. Next, paint midvalue green below this and at the lower edge of the fold. Leave the section in the center free of pigment; this will be the lightest area. Paint a line of light warm green where the fold meets the dark center section. Add a line of midvalue green above the dark line of the horizontal fold to separate it from the dark mass above it. Paint this dark area with darkest blue, glazed with dark olive green. Add midvalue green to the long vertical fold coming down from the center toward the left.

3 Work Around the Main Fold

Add midvalue green to the dark mass above the horizontal fold. Use light green to draw the edges of the lightest area of this fold. Refine the lower edge of this fold where it meets the center. Use the same light green to paint the reflected light around the lower edge of the horizontal fold.

Define Edges With the Same Color

When you need to draw a line to define an edge, use the same value and color as the line to paint strokes away from the line and into the surrounding color. This will help to make the folds appear rounded.

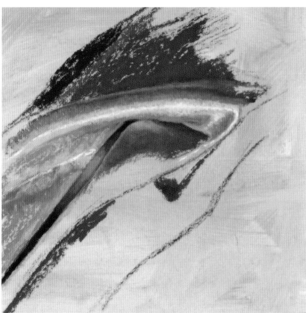

4 Paint the Lightest Sections of the Main Fold

With the lightest warm green, draw a line across the horizontal fold where the light is the strongest. Take this light down and around the left of the diagonal fold, establishing the corner. As you come down the left side, make this a broken line. Long round lines in a composition are boring.

Add light warm green to the outer edges of this line. Make little strokes to lightly blend these values together, taking care to preserve the light. Paint the left section under the fold with dark and midvalue green. Add light blue-green to this area. Using the lightest blue, draw a line of light in the middle of this section. Add midvalue green and warm yellow to the right edge of this area.

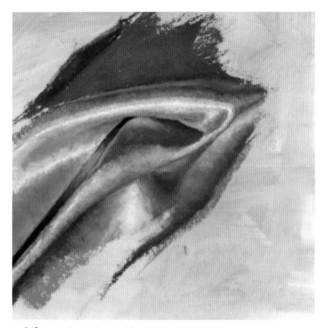

5 Work the Other Folds

Continue working the rest of the folds in the same manner. Paint the darks, then the midvalues, then the lights. Pay attention to the way in which light gradates out from the darkest area of shadow in a fold or crease. You can render this by changing the values in degrees, gradually moving from the darkest area toward the lighter area.

Fur

For this demo, we'll portray the fur collar of a child's sweater. I approach painting fur clothing as I do painting animals: Paint short strokes, following the direction of the hairs. Use the same procedure to paint feathery boas. I chose white fur to demonstrate that white is never white: It picks up color from areas surrounding it. It can also be a good exercise in making colorful grays in the shadow areas.

MATERIALS

SURFACE

8" × 8" (20cm × 20cm) Wallis Sanded Pastel Paper, toned with midvalue olive green

PASTELS

blue (lightest, light, midvalue and dark), blue-gray (light and midvalue), blue-violet (midvalue and dark), raw sienna (lightest), warm brown (light), warm pink (light and midvalue)

REFERENCE
PHOTO

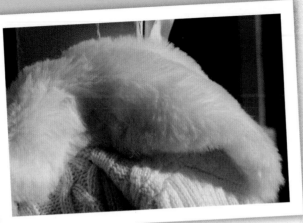

Establish Sections

When painting fur, divide it into workable sections. Don't try to paint every piece of the fur; rather, choose sections to paint with enough detail to render it believable.

1 Establish the Shape

Use dark blue-violet to lightly establish the shape of the fur collar. Then use dark blue to begin lightly establishing the upper area where the main separation occurs. Glaze over this with midvalue blue, then paint into this with light blue. Paint strokes from this area outward and upward with lightest blue. This basic formula is how each section will be gradated.

2 Block In the Shadow Areas

Continue working down this section, using dark blue-violet to block in the shadow areas. Glaze over these areas with midvalue blue-violet. Glaze a bit of light warm brown over the blue of the upper section. Paint strokes of midvalue blue to the right above this area to establish that section. Paint strokes of lightest raw sienna above this separation.

3 Paint the Darkest Section

Paint the darkest section of the collar using strokes of dark blue, midvalue blue, and midvalue blue-violet. Add midvalue warm pink to the upper and lower edges of this section. Add lightest blue to the left side of this section to give it a boundary. Paint into the blue on the upper right with lighter blues and blue-grays.

4 **Work on the Edges**
Paint over the dark areas with midvalue blue and blue-violet to soften the edges. Take care to maintain the edges of the sections. Add midvalue warm pink to the center area where it is reflected onto the collar. Add more light strokes to the left side.

5 **Paint the Area Under the Collar**
Work the section under the collar using dark blue-violet with midvalue blue-violet and blue in the cool areas. Paint the warmer section with midvalue warm pink. Paint into this with lighter warm pink.

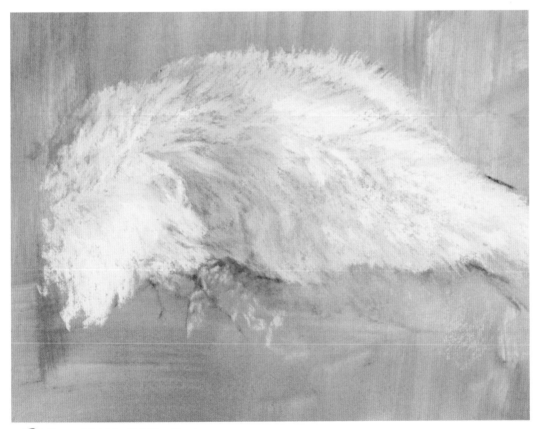

6 **Refine and Add the Finishing Touches**
Continue refining by painting strokes of lightest blue over the cool areas to slightly blend them. Paint strokes of lightest raw sienna over the warm areas of the fur.

Knit Hat

Knits are probably the easiest fabrics to render, because they are dense and do not reflect light as readily as other fabrics. The folds are simpler, and you can suggest the ribs with just a few strokes of color. I paint knits with softer pastels and heavier strokes.

REFERENCE
PHOTO

MATERIALS

SURFACE

8" × 8" (20cm × 20cm) Wallis Sanded Pastel Paper, toned with midvalue olive green

PASTELS

blue-violet (dark), burnt umber (light), cool pink (light), cool red (light, midvalue and dark), red-violet (dark), reddish brown (dark), warm pink (midvalue), warm red (midvalue and dark)

1 **Map In the Hat and Establish Some of the Ribs**
Use dark blue-violet to draw the general shape of the hat. With the same color, establish some of the ribs. They are more pronounced in the darker area of the hat. Notice that the ribs are not straight lines. Start these broken lines at the top; paint the rest of the line from the bottom up. You can see another type of ribbing in the pumpkin in the painting on page 90.

2 **Paint the Ribs and Establish the Far Edge**
Paint over the ribs with dark reddish brown. Make light strokes of the dark reddish brown over the shadow area. Paint a few strokes of midvalue warm red on the far side to establish the edge.

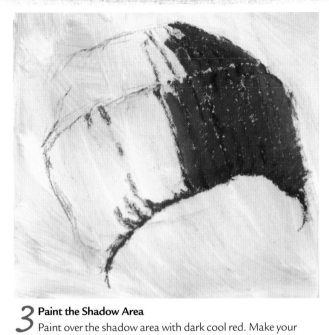

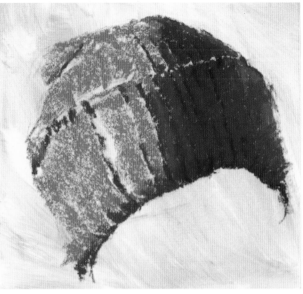

3 Paint the Shadow Area

Paint over the shadow area with dark cool red. Make your strokes short and slightly horizontal between the ribs. Use dark reddish brown to reestablish any ribs that get lost.

4 Paint the Rest of the Hat

Paint the rest of the hat with midvalue warm red. Keep the area above the fold open for the lights. Paint the lower edge of the hat with dark cool red. Use dark cool red to define the top of the lighter side of the hat where it slightly folds. Use dark warm red to define the lower edge of the hat. Use this same red to suggest a few ribs on the lighter side of the hat.

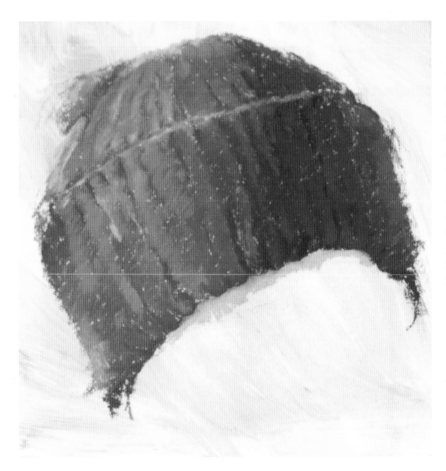

5 Layer Softer Reds and Add Finishing Touches

Continue to layer reds (use softer brands) on both sides of the hat. (Reds in pastel tend to be very hard. Using softer brands will help maintain the knit look of the hat.) Use light pink for the edge of the fold and the highlights on the lighter side. Use a midvalue warm red above the fold on the shadow side of the hat. Add midvalue warm pink and midvalue burnt umber to lightly establish some skin on the forehead. You can use this to refine and correct the bottom edge of the hat. Go back in with dark reddish brown and dark red-violet to make the ribs a little more pronounced on the shadow side.

Plaid

I paint a lot of plaid shirts in my cowboy work. Sometimes, as in this demo, I work all the different colors and stripes. Other times, I paint the values and colors of the shirt as a whole, then put in a few blocks of color to suggest the plaid patterning. It all depends on what my concept is. I use the latter technique more when the figure is farther away, and add more detail in the plaid when the portrait includes only the head and shoulder.

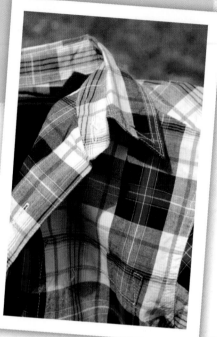

REFERENCE
PHOTO

MATERIALS

SURFACE

8" × 8" (20cm × 20cm) Wallis Sanded Pastel Paper, toned with midvalue olive green

PASTELS

blue (midvalue and darkest), blue-gray (lightest, light and midvalue), blue-violet (dark), brown (light, midvalue and dark), cool red (midvalue and dark), gray (light and midvalue), pink (light), raw sienna (lightest), raw umber (light), red-violet (midvalue and dark), ultramarine blue (midvalue), warm brown (light), warm red (midvalue), yellow (midvalue)

Layering Colors

When glazing two colors over each other, such as in the blocks of a plaid shirt, stroke the first color in one direction and the second color in the other.

1 Outline the Collar and Shadow Area
Draw the outline of the collar area using dark blue-violet. Lightly block in the shadow area with the same dark blue-violet. Decide where you want to start the blocks of color under the collar and mark these.

2 Start the Block Pattern
Paint the lighter blocks under the collar with dark blue-violet, glazed with midvalue blue. Paint the dark blocks with darkest blue and midvalue ultramarine blue. Add a bit of light blue-gray where the light is hitting the lighter blocks. Use dark brown to draw the stripe running through the midvalue set of blocks. Notice that the line is not straight; it bends and moves as the shirt does.

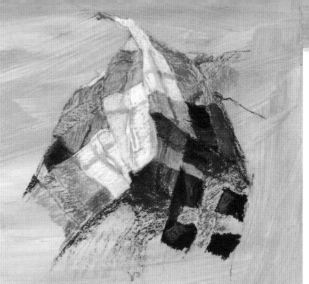

3 Start Adding Pattern to the Collar

Paint blocks of color on the collar, beginning with the area directly above what you just painted. Paint the midvalue blue shapes first, glazing over them with light blue-gray. Paint the dark shape with the darkest blue. Make the red shapes with dark cool red. Paint over the red on the edge of the collar with midvalue warm red. Glaze over the lighter areas of red with light pink. Work up from here by painting the light shape with lightest raw sienna. Paint the light parts of the plaid that are in shadow with light raw umber. Paint the brown stripes over the light blue squares with midvalue warm brown. Go over this lightly with yellow. Paint the yellow stripes over the light squares.

4 Work the Inner Section and Shadow Area

Move to the left of the collar. Paint the dark blocks with midvalue blue-gray. Paint the lighter blocks light blue and the lightest with lightest blue. Paint the red blocks with midvalue cool red.

Continue the process painting to the left of the collar and then down the shadow side. Add more layers to the blocks to adjust the values and colors as needed. Paint the brown stripes in the light blocks with light brown and light raw umber and with dark brown in the darker areas. Lightly outline the buttonhole with light warm brown. Paint a line around this with the lightest raw sienna. Add some light warm brown to the grayer blue blocks.

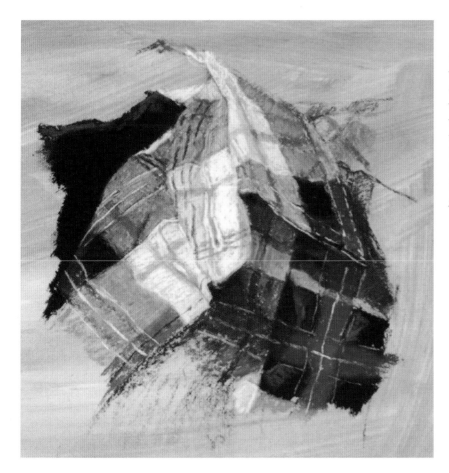

5 Paint the T-Shirt and Add Accents

Paint the dark T-shirt with the darkest blue. Add accents of lighter blue at the edge where it catches light. This is the detail part of a painting; you decide just how much you want. Paint the light lines in the darker areas with light blue-gray. Paint the light lines in the lighter areas with lightest raw sienna. Paint the stitching lines of the collar with lightest blue-gray, leaving them somewhat broken. The edges of Rembrandt pastels are good for fine lines such as these.

Checks

This is another fabric that, as you render it, can either make you insane or be very therapeutic. One option is to just paint the local color and forget the checks. However, this doesn't work if it's a client's favorite dress. In the end, it can be rewarding and fun when you see it come together.

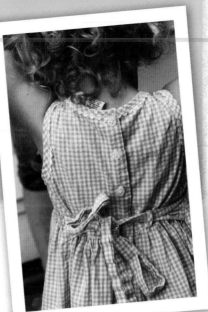

REFERENCE PHOTO

MATERIALS

SURFACE
8" × 8" (20cm × 20cm) Wallis Sanded Pastel Paper, toned with midvalue olive green

PASTELS
blue (lightest), blue-gray (lightest, light and midvalue), blue-violet (light, midvalue and dark), cool pink (light, midvalue and dark), raw sienna (lightest), raw umber (light), red-violet (midvalue and dark), warm pink (light)

1 Mark the Main Elements
With dark blue-violet, mark the position of the collar, back opening and buttons. Mark the bottom of the bodice and the position of the tie.

2 Paint the Major Wrinkles and the Rickrack
With dark blue-violet, define areas of major wrinkles. Add midvalue blue-violet and midvalue red-violet to these. With the light cool pink, begin making lines on the collar. Add dark cool pink to the darker checks.

3 Start Painting the Checks Through the Center
Paint the shapes of the rickrack with light blue-violet in the shadow areas. Paint the lighter areas with light raw umber and light blue-gray. Paint the lightest ones on the left with lightest raw sienna. Accent the lower edges with a few lines of dark cool pink and dark red-violet. Paint the lines coming down from the rickrack with midvalue cool pink. Come across these with light cool pink. Use dark red-violet to paint the line of the button hole. Paint around this with lightest blue. Draw around the outer edge of the button with light blue-gray. Begin filling in the spaces between the pink lines. Paint lighter areas with lightest blue-gray with a bit of lightest raw sienna in the areas where the light hits. For the white spaces in shadow, use light and midvalue blue-gray.

4 Continue Working Through the Center

Continue working down the bodice. Paint the vertical stripes in this area with dark cool pink. After painting the horizontal pink stripes, glaze over the folds with light blue-gray. Stroke upward and outward from the fold. Add midvalue blue-violet to the center between the second and third button. Go over the opening in the center with dark blue-violet and dark red-violet. Draw around the outer edge of the second button with light blue-gray. Add a few specks of dark red-violet for the holes in the button.

Use Less Detail in Bright or Dark Areas

Generally, you will see less detail in spots where the sun reflects most brightly and in shadowed areas. Paint these areas a bit more loosely than the rest of the garment.

5 Finish the Checks and Add the Finishing Touches

Work the rest of the checks. Paint light and midvalue blue-violet over shaded areas. Paint the buttons with light blue-gray. Add lines of dark blue-violet and dark red-violet to suggest the ridges on the buttons. Add dabs of dark cool pink and dark red-violet for the holes in the buttons. Add lightest blue to the top and bottom of the second and third buttons to show the stitching of the buttonholes. Paint a few crisscrossed strokes of lightest blue-gray for the stitching on the buttons. Add a speck of lightest raw sienna for the highlights on the buttons. Add a bit of midvalue blue-gray to the second and third button. Paint the dark area under the tie with dark blue-violet, dark red-violet and dark cool pink. Define the separation of the tie with dark red-violet. Paint a few dark cool pink strokes and a few light cool pink strokes to suggest the checks on the inner part of the tie. Paint the light part of the tie with lightest raw sienna. Paint a few lines of light and midvalue cool pink to show the checks in light.

Vary the Checks

All checks are not equal. Notice where the shapes and sizes differ as the fabric moves and the light hits it. To make the pattern more interesting, vary the checks. Paint them loosely, without drawing them in and filling each square.

Denim

Denim is the fabric that I probably paint the most. Jeans, overalls and jackets are generally made of denim. When painting this ubiquitous material, use light, short strokes following the direction of the weave of the fabric. Also, alternate strokes of different shades of blue in any given area.

REFERENCE
PHOTO

MATERIALS

SURFACE

8" × 8" (20cm × 20cm) Wallis Sanded Pastel Paper, toned with midvalue olive green

PASTELS

blue (lightest, light, midvalue, dark and darkest), blue-gray (lightest, light and midvalue), blue-green (midvalue), blue-violet (dark), brown (light), red-violet (light, dark and darkest), ultramarine blue (midvalue and dark), warm brown (midvalue), yellow ochre (light)

1 Block In the Basic Shapes
With the dark blue-violet, mark the position of the strap, hook, button, body and pocket of the overalls.

2 Begin Painting the Strap and Hook
Beginning with the strap, paint strokes of darkest blue for the darkest areas. Paint midvalue blue-green and midvalue ultramarine blue next to these. Define the hook on both sides with darkest red-violet and dark blue.

3 Refine the Strap and Hook
Paint the light areas of the strap with light blue. Add a fine line of midvalue blue to the bottom edge of the strap to help it come forward. Paint the area below the strap with dark blue-violet. Add strokes of dark blue and light blue as shown. Paint over the hook with light blue-gray. Paint the dark fabric on the underside of the garment with darkest blue.

4 Start Defining the Body, Pocket and Button

Add detail with red-violet to define the hook. Paint the dark shapes of the seam with darkest blue. Paint strokes of midvalue blue into these. Paint strokes of light blue and lightest blue-gray into these. Draw a line with dark blue for the inner edge of the seam. Paint strokes of midvalue blue above the button. Draw the outer edge of the button with light blue to define it.

With the darkest blue, paint the darkest areas on the pocket and above it. Use the darkest blue to paint the area underneath the button and along the seam line down the right side. Paint strokes of midvalue blue next to the darks. Add shapes of midvalue blue on the upper edge. Paint short strokes of midvalue blue, moving away from the dark seam. Add lighter blue-gray over this. Paint the outer edge of this seam with midvalue blue. Paint a line of light blue-gray on the edge. Paint a dark blue line on the outer seam line. Using light warm brown, add a broken line of color along the seam lines of the outer right edge of the overalls. Continue to define the hook with lightest blue-gray. Bring the lower edges of the hook around the sides of the button.

5 Refine the Body, Pocket and Button

Paint the detail on the fabric of the inside of the overalls with a few well-placed strokes of midvalue blue. Work the area to the left of this by painting the darkest area of the fold first with the darkest blue. Paint strokes of dark blue-violet down and away from this. Finish with strokes of light blue and lightest blue-gray. Paint the overturned edge with dark blue. Add a fine line of lightest blue-gray to define the edge. Add light blue highlights. Finish the body of the overall by painting strokes of different shades of blue side by side. Paint the right seam of the pocket as the seam below the button. Paint the folds, carefully modeling and gradating first with the dark values, then the midvalues and finally the lights. Paint the stitch lines with midvalue warm brown in the darker areas and light yellow ochre in the lighter areas. Draw some detail in the button with dark blue-violet and red-violet.

6 Add the Finishing Touches

Paint the button using lightest blue-gray. Add lightest blue on the right side. Add light red-violet to the left. Add a few strokes of light red-violet on the outer edge of the right seam. Put a bit of this along the upper left edge of the overall and on the upper edge of the pocket. Place a few strokes of light red-violet on the hook. This will add interest to a composition that is basically one color.

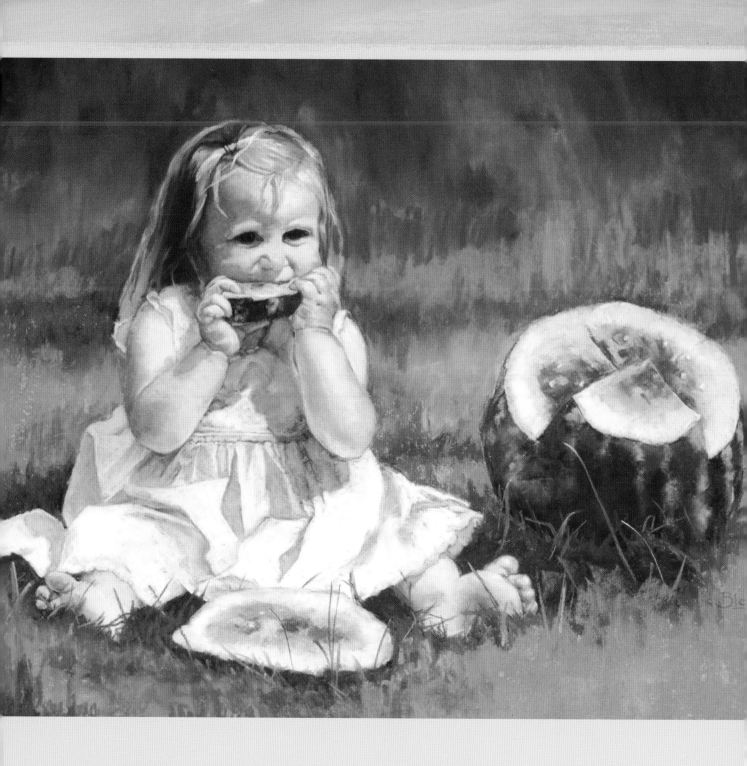

8

Putting It All Together

In this chapter, you will find three demonstrations of the whole figure. Make thumbnail sketches to help you determine the most pleasing placement of the key elements. With sketches, you can easily experiment, moving your objects until you are happy with the composition. You can decide on the format of the surface and determine how much space you want on all four sides of your subject. Will you use a horizontal or vertical composition? Will it need to be long and narrow or tall and wide? Preliminary sketches will not solve all of your problems, but they will help you avoid many dilemmas before you put pastel to paper.

WATERMELON
Pastel on Wallis Sanded Pastel Paper
16½" × 23" (42cm × 58cm)

Seated Figure

Dzifa is a very poised young lady of seven, shown here on her grandmother's porch. The light comes from a south-facing window, which makes the shadow areas warm, while the highlights are cooler. I think the cool pale green of the wall makes a great contrast to Dzifa's warm skin tones.

REFERENCE PHOTO

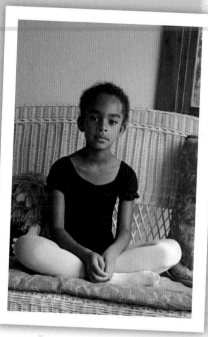

MATERIALS

SURFACE

24" × 18" (61cm × 46cm) Wallis Sanded Pastel Paper, toned with midvalue olive green

PASTELS

blue (lightest, light, midvalue and dark), blue-gray (lightest), blue-green (light and midvalue), blue-violet (lightest, light, midvalue and dark), brown (light and dark), burnt umber (lightest, light and midvalue), cool pink (lightest and light), gold ochre (midvalue), green (light, midvalue and dark), raw sienna (lightest), raw umber (midvalue), red (dark), red-violet (light, midvalue and darkest), reddish brown (light and dark), warm brown (midvalue and dark), warm pink (midvalue), warm red (light and midvalue), yellow ochre (midvalue)

BRUSHES

small, soft fan brush

PRELIMINARY SKETCH

Preliminary sketches allowed me to see that most had awkward hand positions that were not evident at first. The sketches also helped me decide to leave more space at the bottom of the composition and to change out the character on Dzifa's right with another pillow.

1 Map the Position of the Head and Body

Using dark blue-violet, map Dzifa's head and basic body positions on the paper. Place the top of the head approximately 4" (10cm) from the top of your paper, slightly off center. The head measures about 5¼" (13cm) from the top of the hair to the bottom of the chin. Use the length of the head and plumb lines to place the arms, hands and legs. Mark general placement lines at this time. It's important to determine right at the beginning how the width of your subject compares with the height. Notice that the width from knee to knee is a bit more than three-quarters of Dzifa's height.

2 Paint the Face, Hair and Eyes

Paint the face, beginning with the dark areas. Use dark blue-violet to lightly suggest the shadows, then paint over this with midvalue reddish browns, midvalue warm red and midvalue warm brown. Paint her hair and eyebrows with darkest red-violet and dark brown. You will work the top of the hair at the same time you paint the background. For the midvalue areas, use warm red, gold ochre and warm pink. Use midvalue warm brown to subtly bring the areas together. For the lighter areas, use midvalue and light burnt umber. Paint the highlights with lightest pink. Use a background color such as light blue-green to help define outer edges such as around the hair and ears.

Paint Dzifa's eyes with darkest red-violet and dark brown. Use a bit of light reddish brown in the lighter areas at the bottom of the irises. You could also use a dark orange for the same effect. Add a bit of midvalue yellow ochre to the lightest area of Dzifa's left iris. Use lightest blue-gray for the highlight in the iris and lightest raw sienna for the speck on the pupil.

3 Paint the Neck and Begin the Leotard

Mark the neck, carefully observing where it comes down from the face. Use a fan brush to determine the angles of the shoulders. Paint the shadows on the neck with dark blue-violet, followed with dark reddish brown. Draw the top of the leotard using the nose-to-chin measurement to determine how far from the chin it should be placed (it's about two times the distance from nose to chin). Also, use your paintbrush as a plumb line to see where the center dip of the leotard hits. It lines up slightly to the right of the corner of Dzifa's right eye. Begin the top of the leotard with darkest red-violet. Draw in the sleeves with dark blue-violet.

4 Paint the Leotard and Mark the Arms

Paint the darkest areas of the leotard with darkest red-violet. Paint the main area of the leotard with dark blue. Use light blue, midvalue blue-violet and midvalue red-violet to paint the lightest areas. Mark the arms. Use dark blue-violet to lightly block in the shadows on the arms.

Filling the Tooth With Darks

It might be necessary to blend with your finger to get the darks to fill the tooth of the paper. Paint strokes of color back over the blended area so that it doesn't become flat and boring.

5 Finish the Leotard
Paint the rest of the leotard, stopping just above the forearms. Wait to paint this until after the arms are in.

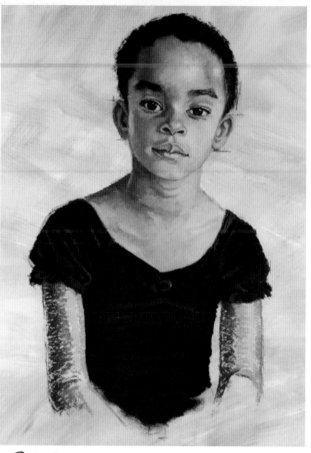

Foreshortening Advice

When painting arms that are foreshortened, as in this demo, pay close attention to the direction and length of each angle. Use the distance from the nose to chin to determine the length between each change in angle. Then, keeping your brush tilted at the same angle as the line in the reference photo, move your brush from the photo to your paper and mark the line.

6 Paint the Upper Arms
Paint the arms, layering dark blue-violet and reddish brown for the shadows. Paint a layer of warm red next to the right edge of the shadow on Dzifa's right arm. Paint the inside of the same arm with midvalue warm pink. Paint the light area with midvalue and light burnt umber. Use midvalue warm brown to blend the shadow areas together. Use midvalue burnt umber to gently blend the lighter colors together.

7 Paint the Forearms and Mark the Upper Legs
Paint the forearms in the same way as the upper arms. Begin with dark blue-violet in the shadows, followed by warm red. Paint the midvalue areas with midvalue warm pink and midvalue burnt umber. Glaze over the arms lightly with raw umber to keep the arms cooler than the face. Mark the position of the hands with dark blue-violet. Begin marking the upper legs.

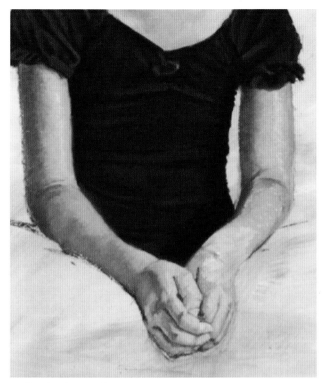

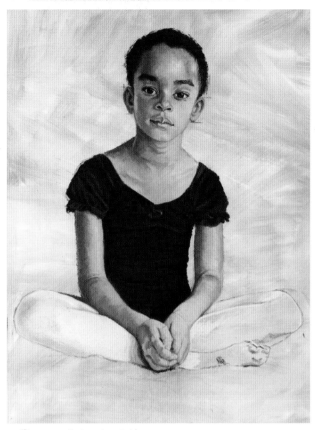

8 Paint the Hands

Paint the hands using dark blue-violet and dark reddish brown for the dark areas. Paint the midvalue areas with warm red and midvalue burnt umber. Paint the light areas with light burnt umber. Use light blue-violet for the reflected light on Dzifa's right hand. Glaze over the light areas with lightest raw umber to keep the color subdued.

9 Start Painting the Tights

Paint the darkest shadow area of the tights with dark blue-violet, glazed with midvalue red-violet. Paint the area on her right knee with midvalue blue-violet, light cool pink and light blue. Blend these slightly together with a hard light blue pastel. Use light warm pink where you can see some skin tone coming through the white of the tights. This is another area where you may choose to do some blending with your finger—but take it easy. Texture makes a more interesting painting.

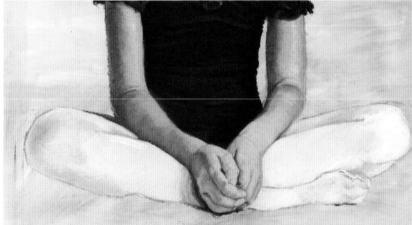

10 Continue Painting the Tights

Use the nose-to-chin measurement to determine the width of the different sections of the leg and foot. Paint the front area of the foot, using dark blue-violet to mark where the toes are. Gradate out from this with midvalue blue-violet and light red-violet. Blend the colors together with lightest burnt umber. Paint the lightest area of the tights with lightest burnt umber in the warmer areas and lightest blue in the cooler areas.

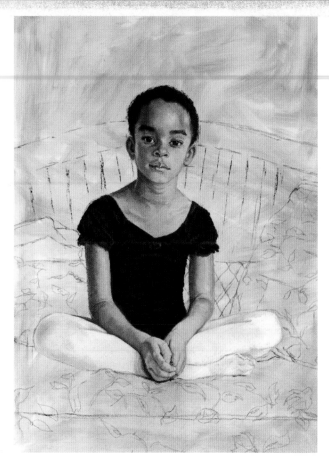

11 Block In the Background

Draw in the background elements with dark blue-violet. Draw a pillow on Dzifa's right. Change the angle of the other pillow to add interest. Draw in the general shapes of the floral pattern. Be free and have fun with this. It doesn't need to be perfect or exact. It will also be more interesting to have the front of the cushion extend down instead of showing wicker at the bottom.

Edges and Transitioning From Surface to Surface

You should have a combination of hard and soft edges in any painting. Edges are softer in shadow and crisper or harder in the light.

Transitioning from one surface to another, such as where the skin hits the clothing, takes great care. Value changes are key. Look for places where the clothing casts shadows on the skin, such as under the sleeve or along the neck edges. These edges will be softer. You can achieve this by laying a line of pastel over the clothing in the color and value of the skin. The edge where the skin is lighter will be harder, so keep the colors and values clean in these areas.

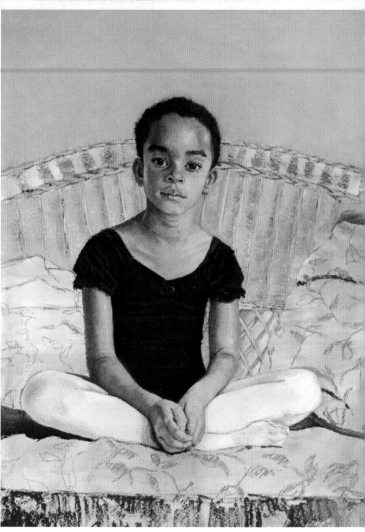

12 Paint the Lighter Background Elements

Paint the background behind Dzifa's head with a combination of light greens and blue-greens. (There are many varieties of green and blue-green; I think it adds interest to use more than one shade of each.) Using a darker value, add more blue to the left side of the background. Make the color gradually lighter as you work toward the right. Paint some strokes of dark green in the shadow portion of the lower cushion. Paint the shadow under Dzifa's right knee with dark green and dark blue. Begin marking the shapes in the wicker with dark blue-violet. Add midvalue blue and midvalue raw umber to the lighter areas. Make strokes of midvalue warm brown to lay in the leaves on the fabric. Use dark green to make the shadows in the fabric. Paint the pink of the pillows with dark reddish brown, midvalue warm red and light warm red.

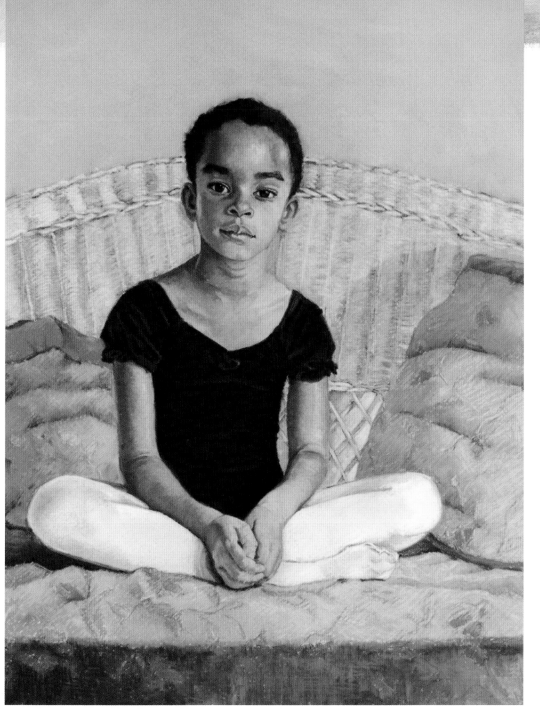

13 Refine the Background Elements

Finish painting the fabric by crosshatching strokes of various dark blues and greens in the darker areas. Use a variety of hues to establish the texture of the shaded areas of the fabric. Crosshatch strokes of a variety of light blue-greens in the lighter areas. Paint a few strokes of light warm pink in the light areas and darker warm red in the dark areas. Paint strokes of light burnt umber on the leaves in the light. Paint strokes of dark warm brown on the leaves in shadow areas. Paint the flowers with midvalue warm pink in the light areas, adding accents of light cool pink. Paint the flowers in the darker areas with warm red, adding accents of dark reddish brown.

DZIFA IN BLACK LEOTARD
Pastel on Wallis Sanded Pastel Paper
24" × 18" (61cm × 46cm)

Figure With Varied Fabrics

I like the interesting way Isabella is holding her hands against her face in this photo. I also like the turn of her head and the angle of her body. The interior light is soft, which makes the values of the face more gradated and its shapes less defined. This will be a challenging demo because the shapes are not strong and distinct. The checks, smocking and quilt patterns also present challenges. I chose the surface with gray-blue tone because Isabella has more blue tones in her skin than green. This tone will also aid in painting the quilt.

REFERENCE
PHOTO

MATERIALS

SURFACE

18" × 14" (46cm × 36cm) Wallis Sanded Pastel Paper, toned with gray-blue

PASTELS

blue (lightest, light, midvalue and dark), blue-gray (lightest, light and midvalue), blue-green (light and midvalue), blue-violet (midvalue and dark), burnt umber (light, midvalue and dark), burgundy (dark), cool brown (light and dark), cool pink (lightest, light, midvalue and dark), gray-blue (midvalue), green (darkest), olive green (light, midvalue and dark), raw sienna (lightest and light), raw umber (light and midvalue), red-violet (light, midvalue, dark and darkest), reddish brown (midvalue and dark), warm brown (midvalue), warm pink (lightest, light, midvalue and dark), warm red (midvalue and dark)

1 Map the Position
Map the position of the top of the facial features, ear and arm.

2 Block In Dark Areas
Lightly block in the darkest areas of the face and hair with dark blue-violet. Make sure you are satisfied with the likeness (see Achieving a Likeness, page 60).

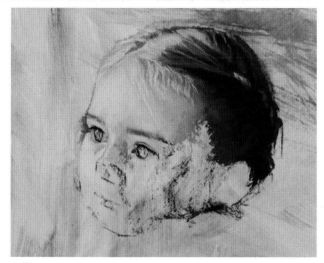

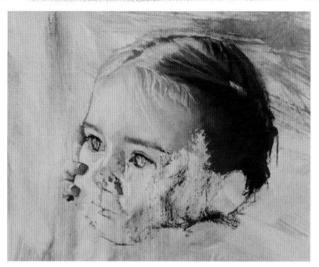

3 Begin the Hair and Face

Paint the darkest darks of the hair with darkest red-violet. Paint into this with dark cool brown. Paint the midvalue areas with midvalue warm brown. Paint into this with light burnt umber for the light area at the top of the head. Add a few accents of light blue-gray at the top. To help the lightest strands of hair stand out away from the face, paint under them with midvalue burnt umber and light warm pink. Paint the eyebrows with midvalue blue-violet glazed over with midvalue cool brown. Paint the darker area of the skin on the forehead with midvalue warm pink. Paint into this with light warm pink and midvalue burnt umber. Paint the lightest area with lightest raw sienna. Paint the eyelashes with darkest green, then add a bit of the darkest green to the pupil. Using midvalue warm red, begin the shape of the finger at the edge of the left eye.

4 Paint the Fingers

Using midvalue warm red, establish the shape of the fingers resting on the face. Paint the rest of the fingers with midvalue and light burnt umber. Add a touch of dark reddish brown to define the nails. Paint the nails with lightest raw sienna and a touch of lightest blue-gray. Paint the near side of the nose with midvalue blue for the shadow. Paint the nostril with midvalue warm red. Add midvalue warm pink and light burnt umber to the rest of the nose. Paint the far side of the face with midvalue and light burnt umber. Add a touch of midvalue warm red under the fingers to plant them.

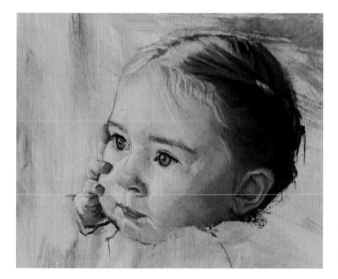

5 Finish the Face and Ear

Paint the rest of the face using dark warm pink with midvalue red-violet on the shadow side. Paint the midvalues with midvalue warm pink and midvalue burnt umber. Add light and midvalue blue-gray to the cool areas around the eyes and mouth. Paint the ear with dark reddish brown, warm red, midvalue warm pink, and light raw sienna. Work the palm of the hand, using dark reddish brown for the darkest area next to the face. Paint the lighter area of the palm with midvalue warm pink and light raw sienna. Paint into this with midvalue warm pink. Paint the outer ring of the eyes with darkest green. (Don't worry about making a clean line.) Paint inside this with a combination of midvalue blue-gray, midvalue blue and blue-green. Add specks of light blue-green across the pupil at the top. Add a few specks of light warm pink at the lower edges of the irises. Make the highlights with lightest blue-gray. Paint the whites of the eyes with light blue-gray. Paint the mouth with midvalue warm red and midvalue warm pink with a bit of lightest cool pink for the lightest area on the bottom lip. Paint the separation of the lip with dark red-violet.

Ol' Blue Eyes

Blue eyes are not just blue. They generally pick up some color from surrounding areas, including clothing. This is especially true of lighter shades of blue. Notice what other colors may be added to achieve a more interesting, natural look.

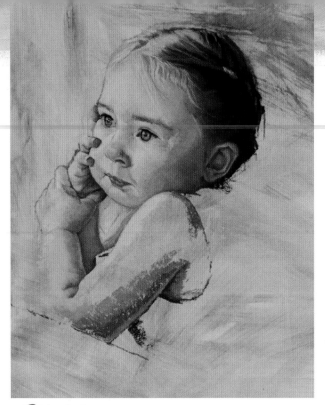

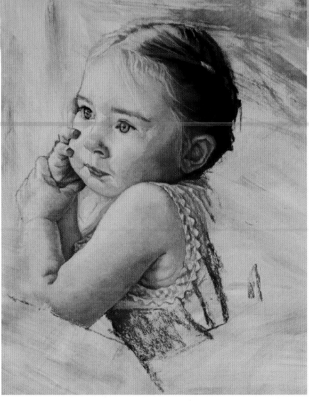

6 Paint the Arms

Use midvalue red-violet and warm red to paint the inside of the right arm. Add accents of midvalue blue-violet to give the feeling that this arm is behind the other. Work this shadowy area around the front part of the dress. Paint the darkest areas of the left arm with dark reddish brown and midvalue red-violet. Paint into this with midvalue warm pink. Paint the midvalue areas with midvalue burnt umber and midvalue warm red. Define the armhole of the dress with dark blue-violet.

7 Begin Painting the Dress

Using light burnt umber and lightest raw sienna, paint the lightest area of the left arm. Add midvalue blue-violet to the top of the shoulder. With dark cool red and dark blue-violet, paint the shadow and fold areas of the dress. Use dark red-violet to make a very thin line at the outer edge of the arm opening to set it apart from the dress. Paint the checks with dark, midvalue and light cool pink. Paint the lightest areas between the checks with lightest cool pink. Paint these areas with light and midvalue blue where they are in shadow. Paint the rickrack with light blue and lightest blue-gray. Add midvalue blue at the inner edge.

8 Work the Folds of the Dress

Continue working the dress, painting the dark areas of the folds with dark red-violet and dark cool pink. Use light slanted strokes to paint the shadow area of the front of the dress with dark red-violet; paint into this with dark cool pink. Keep working differing values of pinks and reds with slanted strokes to make the base for the smocking.

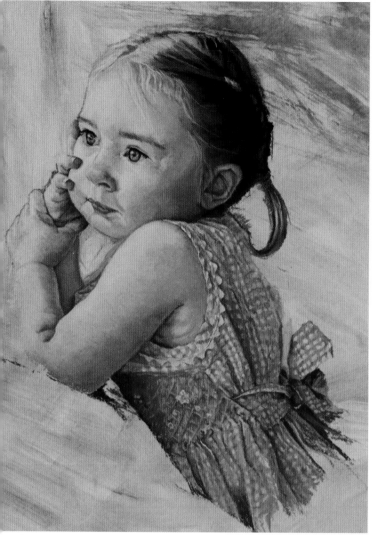

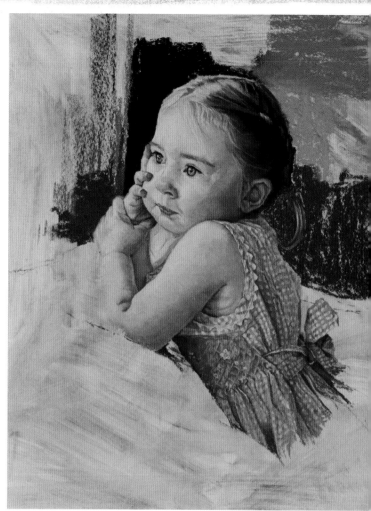

9 Add Smocking Details

With light cool pink, paint lines diagonally across each other for the smocking. Add darker cool pink underneath the lines to make them appear to have dimension. Add some dabs of light blue-gray for the light flowers. Paint the leaves with midvalue and light olive green. Paint the ponytail with dark warm brown in the darkest area. Add midvalue warm brown to this. Paint the light area with light burnt umber. Paint the ponytail holder with midvalue red-violet and a touch of midvalue warm brown.

10 Begin the Background

Using darkest red-violet and dark warm brown, paint the area around the face. Use light burnt umber to go back over the edge so the face doesn't look cut out. Paint the area to the left of this and the area at the back of the head with midvalue olive green. Paint the area behind the dark part of the head with dark and midvalue burnt umber. Add some dark burnt umber to separate the dark area from the olive green on the left.

Background Decisions

In general, background objects in a portrait like this one will become a distraction unless you paint them as abstract shapes. You get to choose what to leave out. I chose olive green for this background to provide a nice contrast to the flesh tones of Isabella's skin and the pink of her dress. The olive tone also helps to eliminate some of the "sweetness."

11 Blend the Background and Begin the Quilt

Add midvalue gray-blue and dark warm brown to the background. Blend the background as needed to cover the blue tone. Use light cool brown and light red-violet to define the patches and folds of the quilt. Paint out from these with light values of various blues. Add lightest blues in the centers to show how the stitched sections puff up. Add dark and light cool pink on the pink patches. Paint dark and midvalue blue on the blue patches.

12 Block In the Couch and Continue the Quilt

Block in the couch area in the lower left corner with dark warm brown. Add touches of dark blue-violet at the lower edge of the quilt to separate it from the couch. Paint the light trim of the quilt with light blue and lightest blue-gray. Continue working the quilt to the lower edge. Paint the part of the quilt behind the subject with midvalue blue. This area does not need any detail.

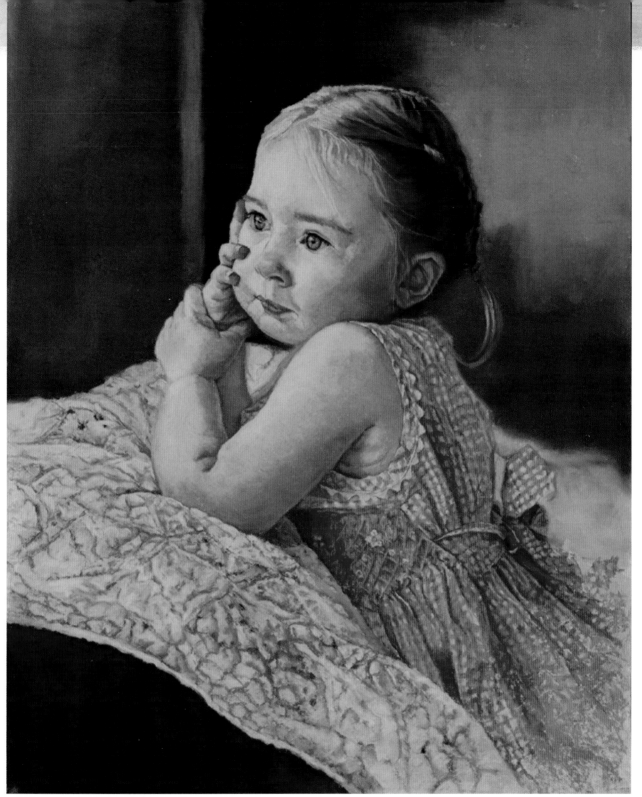

13 Add Finishing Touches

Finish painting the quilt by continuing to define the pattern with light cool brown and light red-violet. As you work the outer areas of the top and bottom of the quilt, paint with less definition and larger areas of color. Use darkest red-violet, dark cool reds and warm brown to paint the couch. Finish the fabric by suggesting checks as the dress flows down and out of the picture.

DAY DREAMIN'
Pastel on Wallis Sanded Pastel Paper
18" × 14" (46cm × 36cm)

Editorial Changes

The reference photo shows the back part of the quilt under the subject's chin, but it looks awkward. I chose to paint a wedge of dark brown and olive green there instead.

Figures With Curly Hair

These children were playing in the grass while they were waiting for me to photograph them. You can tell they are best friends as well as siblings. I like the pose of the boy, Ydidia, in the first reference photo, but didn't like the way Nazrawit's forehead appears. I chose to use her position in reference photo 2. I sketched out this composition full size to deal with any potential problems with the leg and hand positions.

The most challenging part of this painting is the hair. The children are of Ethiopian descent on their mother's side, and their hair is very curly. Remember to simplify by deciding which sections are important to the overall feel of the hair. I chose to paint quite a bit, but you may prefer to paint the whole and suggest only a few curly strands.

MATERIALS

SURFACE

16" × 20" (41cm × 51cm) Wallis Sanded Pastel Paper, toned with mid-value olive green

PASTELS

blue (lightest, light, midvalue and dark), blue-green (midvalue), blue-violet (light and dark), burnt umber (lightest, light and midvalue), cool brown (midvalue), gold ochre (light and midvalue), gray-blue (midvalue), olive green (midvalue and dark), raw sienna (lightest and light), raw umber (light), reddish brown (dark), red-violet (light, midvalue, dark and darkest), warm brown (midvalue and dark), warm pink (light and midvalue), warm red (midvalue and dark), warm white (lightest), yellow-green (light, midvalue and dark), yellow ochre (midvalue and dark)

REFERENCE
PHOTO 1

REFERENCE PHOTO 2

1 Map the Basic Placements
Use dark blue-violet to mark the important placements of the figures. Use reference photo 1 to determine the size difference of the boy's head in comparison with the girl's. The little girl's head size is about three-fourths that of the boy's. Mark the left edge of the girl's head about one head-width from the boy's face.

Combining Reference Photos

When combining photos to paint more than one figure, you will need reference photos with all figures posed together to determine size differences. This is especially important when the age and size difference is significant. The head size is the most important thing. Once you determine the proportional differences between the heads, you can then determine the proportions for each individual figure. (See page 26 for more about combining reference photos.)

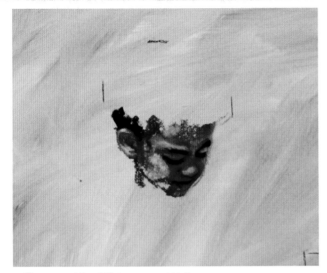

2 Start With Ydidia's Face and Hair

Using darkest red-violet and dark warm brown, paint the dark area of Ydidia's hair, the eyebrows, eyelashes and separation of the mouth. Paint the darker areas of his face with midvalue warm brown and midvalue red-violet. Paint the darker areas on the cheeks with dark warm red, midvalue warm brown and dark gold ochre. With midvalue and light gold ochre, paint the midvalue areas. Paint the mouth with midvalue warm red and midvalue red-violet. Add lightest burnt umber to the light areas on the ear.

3 Continue Painting the Hair

Paint the dark areas of the hair with darkest red-violet and dark warm brown. Choose the sections of hair that are most important. With midvalue warm brown, paint where the curls come out from the head. Paint the center of the curls with light warm brown. Add light accents with light burnt umber and lightest raw sienna. Paint the cast shadow from the hair on the forehead with midvalue red-violet and midvalue warm brown. Paint the shadow under the neck with dark blue, dark red-violet and midvalue warm brown. Paint the shadow area of the shirt on Ydidia's left shoulder first with dark blue-violet, then with midvalue blue. Paint the midvalue area with midvalue blue.

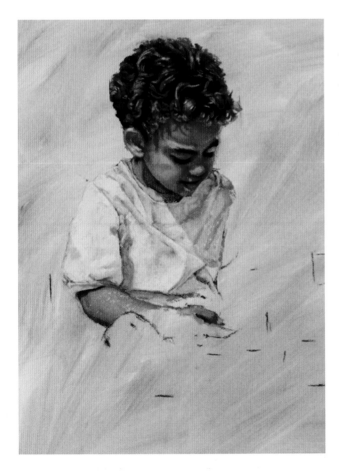

4 Paint the Shirt and Arm

Paint the folds in the shirt with dark blue-violet glazed over with midvalue blue. Add a bit of midvalue blue-green. Paint the shadow areas with midvalue blue. Paint the lighter areas of the shirt with light blue. Begin painting the arm using dark blue-violet and dark reddish brown under the sleeve of the shirt and along the lower edge. Paint next to these areas with dark warm red. Paint into this with dark pink. Add a dab of midvalue red-violet to the indent in the elbow. Begin the hand. Use dark blue-violet to establish the position of the knee.

First Things First

Establish the main figure in a composition first. Everything else will flow out from this.

6 Start Painting Nazrawit's Face

Using midvalue blue-violet and warm pink, paint the shadow areas of Nazrawit's face. Use darkest red-violet and dark reddish brown to paint the eyelashes and the separation of the mouth. Paint a dab of midvalue warm red under her eye. Paint the lower lip with dark cool red. Paint the light areas of her face with light gold ochre and light raw umber.

5 Paint Ydidia's Hands

Use dark blue-violet and dark red-violet to paint the shadow under the sleeve of the right arm. Paint the dark area of the shorts above the arm with dark blue-violet and midvalue olive green. Paint the midvalue of the shorts with midvalue gray-blue and midvalue and light raw umber. Paint the definition between the fingers of the hands with dark reddish brown. Paint next to this with midvalue warm red. Add midvalue gold ochre and midvalue burnt umber to the midvalues on the hands and arms. Add light burnt umber and lightest raw sienna to the lights of the arms, hands and fingernails. Use dark blue-violet and midvalue warm brown to begin forming the bone structure of the knee.

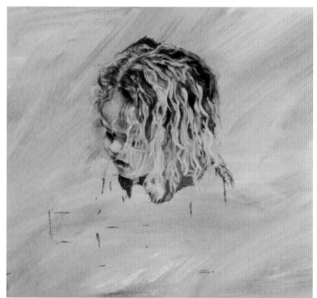

7 Paint Her Hair

Paint the dark sections of Nazrawit's hair with dark red-violet and dark reddish brown. Paint the skin of the part in her hair and at the top of the forehead with midvalue warm pink. Paint the midvalue areas of the hair with cool midvalue brown and midvalue red-violet. Add light blue-gray to the upper edge on the far side of her head. Paint the lightest areas with lightest raw umber and light-est raw sienna. Add accents of midvalue and light warm brown to some of the strands.

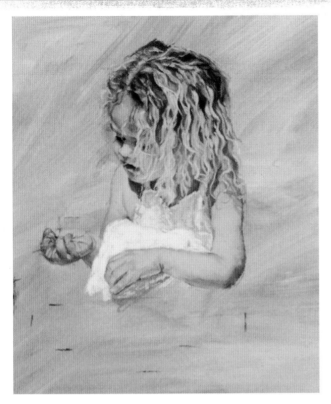

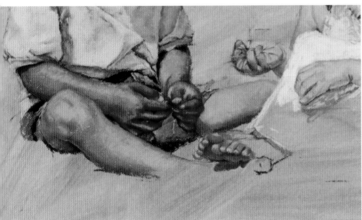

8 Refine the Shadows and Edges

Paint the shadow under the head with dark blue-violet, dark red-violet and midvalue warm red. Begin the upper part of the dress with midvalue blue and midvalue blue-gray. Paint the upper edge with a thin line of dark blue-violet painted over with dark reddish brown to separate the dress from the chest. Paint the shadow areas of the arms and hands with midvalue warm red and midvalue blue-violet. Paint the main areas of the hands and arms with light raw sienna and light raw umber. Add accents of midvalue warm brown to define the outer edges. Paint the definition between the fingers with dark reddish brown. Add midvalue warm red to the underside of Nazrawit's right hand. Paint the grass in her hand with midvalue and light greens. Paint the cast shadow from the grass with midvalue warm red and light red-violet. Paint the lower part of the dress with lightest warm white. Paint the shadow under her left hand with dark blue-violet, midvalue blue and midvalue red-violet.

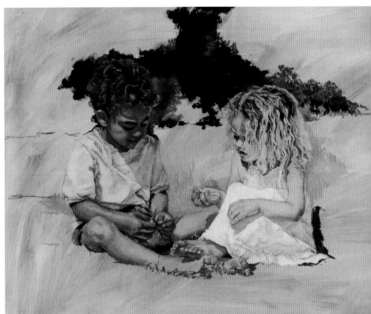

9 Paint Ydidia's Legs

Paint the shadow areas of Ydidia's legs with midvalue cool brown and midvalue blue-violet. Paint into this with midvalue burnt umber and midvalue gold ochre. Use midvalue warm pink and midvalue burnt umber to paint the front of the knee. Paint the lightest areas of the legs with light burnt umber. Finish the shorts by painting the shadow areas with dark olive green and dark blue-violet. Paint the lighter areas with midvalue raw umber and midvalue blue-gray. Add a bit of midvalue blue-green for interest. Add lightest blue-gray to the lightest area of the shorts. Paint Nazrawit's toes with midvalue burnt umber and midvalue warm pink. Add light burnt umber to the light area. Define the toes with dark reddish brown. Add light red-violet to the area under the toes. Paint the cast shadow from the feet on Ydidia's leg with midvalue warm red and midvalue blue-violet.

10 Finish Nazrawit's Feet and Begin the Background

Finish painting Nazrawit's feet with light warm pink and light burnt umber. Paint the cast shadows on Ydidia's leg, Nazrawit's upper legs, and Ydidia's foot with midvalue warm red and midvalue blue-violet. Begin Ydidia's toes with midvalue burnt umber, midvalue warm pink, and midvalue warm red. Add strokes of midvalue olive green under the figures for the grass. Use darkest red-violet and dark cool brown around the heads. Paint a variety of midvalue greens into this area. Begin to establish the roses on the left side with midvalue cool red.

11 Continue the Background

Continue working the upper background with darkest red-violet. Paint into this with dark blue-green in the upper left corner. Paint dark blue-violet over midvalue warm brown to create the cast shadows from the vegetation under the rose bush. Paint the open area of the upper right background with midvalue and light greens, glazed over with light blue-violet. Paint the sky with light blue-green. Add midvalue blue to the top edges of the trees and the open spaces of the roses at the upper right. Paint the ground at the upper right with midvalue warm pink glazed lightly with light blue-violet. Use midvalue warm browns and light burnt umber to establish the ground at the upper left. Continue to add midvalue and light cool reds and cool pinks to the roses. Add light olive green and light yellow-green to the areas where the light hits.

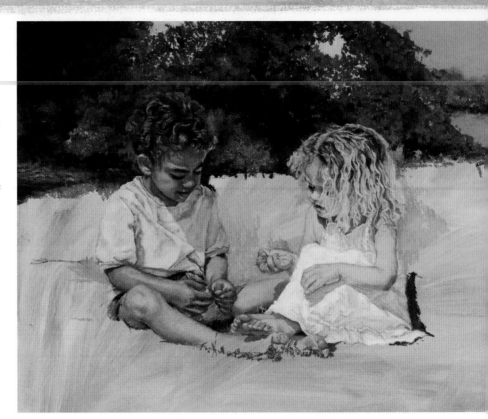

12 Add Texture to the Ground

Add vertical strokes of various light and midvalue greens to the middle and foreground. Paint a few horizontal strokes of midvalue yellow ochre and light warm brown to add depth. Finish Ydidia's lower leg and feet with light burnt umber. Add accents of dark green to plant the figures under Ydidia's shorts and leg and at the lower edge of Nazrawit's dress.

13 **Blend the Foreground**
Paint midvalue green in the foreground. Blend the strokes together just enough to cover the undertone.

SUMMER DAYS
Pastel on Wallis Sanded Pastel Paper
16" × 20" (41cm × 51cm)

Conclusion

When my work on this book was almost completed, I took a little trip to enjoy some sunshine after a very long winter. A woman I met on the trip found out that I'm an artist and asked, "So, what is the secret to painting children?" I just stood there, my mind spinning. What is the secret? Is there one key to answer all your questions? Can you compress it down into one intelligent statement?

Well, I couldn't find a simple answer that day and it set me thinking. How do you narrow down a process into one quick answer? Is there one aspect of painting children that is more important than all the others? As I have since pondered the question, the first and most important idea that keeps coming back is that you have to have a passion for what you do: You have to love children. You have to get excited by the light falling on a little one's hair or the challenge of capturing sparkling green eyes.

Then, there is the technical side of the question, and there isn't one magic answer here either. There are a lot of parts that you must put together. First, you have to teach yourself how to see. Then you have to paint and paint and paint. You need to give up worrying about how others will look at your work or if you will make mistakes. This is part of being human. You have to be good to yourself and patient. Give yourself time to observe and learn and grow. You have to let yourself ruin paper and use up pastel. There is a painting hanging in the Denver Art Museum that had become a favorite in my family, a must-see anytime we're in Denver. One day, an art student showed me a glaring "flaw" in the proportions of the leg in one of the figures. The flaw didn't make me love the painting less. I imagined the artist painting the subject from life over the course of several days, without realizing the model had changed the pose slightly, thus creating a slight distortion. It was encouraging to me that a great artist and painting master was not perfect.

Creating art is a gift and a lifetime adventure. I would love to be a cheerleader and encourage everyone with the slightest interest to buy supplies and dig in. Read books, take classes and be good to yourself.

EARLIEST MOMENTS
Pastel on Stonehenge Paper
12" × 15" (30cm × 38cm)

Index

Backgrounds, 16, 23–24, 48, 74, 86, 112–113, 117–118
 outdoor, 26–27, 123–124
Blending, 17, 48–49, 94–95, 109

Clothing, 67, 71, 91
 dresses, 102–103, 114, 116–117, 119, 123
 hats, 65, 98–99
 leotard, 108–109
 overalls, 104–105
 shirts, 100–101, 121
 tights, 111
 tutu, 92–93
 See also Fabric
Color, 17, 21, 37–45, 85
 complementary, 18, 40
 mixing, 38–39, 41
 schemes, 40
 skin–tone, 37, 41, 43–45
 temperature, 42, 74, 108
 white, 96–97
 See also Pastel
Color wheel, 38–39
Composition, 22, 26, 87, 105, 108, 120
 See also Mapping
Contrast, 23–25, 42, 74, 108–113, 117

Detail, 12–15, 103
Drawing, 76, 87
 See also Sketching

Edges, 35, 47, 51, 66, 95, 112

Fabric, 91, 112–113
 checked, 102–103, 114, 116
 denim, 104–105
 folds, 92–95, 116
 fur, 96–97
 knit, 98–99
 plaid, 100–101
 quilted, 114, 118–119
 satin, 94–95
 smocked, 114, 117
 tulle, 92–93
 See also Clothing
Faces, 30, 47–55, 115, 121–122
 mapping, 29, 31–35, 60, 64, 68
 See also Hair; Skin tone

Facial features
 ears, 54–55, 62, 115
 eyes, 30, 33, 48–49, 61, 68, 71
 eyes, blue, 115
 mouth, 33, 50–51, 62–63, 70–71
 nose, 24, 32–33, 53, 60, 62, 69
 teeth, 52
Fingernails, 79, 81, 86
Fingers, 78–79, 83–84, 115
Focal point, 22, 26, 76, 81
Foreshortening, 110
Fur, 79–80, 96–97

Glazing, 17, 100
Golden mean, 22, 76, 81
Ground, 12

Hair, 34–35, 115
 bangs, 68–69
 blond, 44
 curly, 56–57, 120–122
 dark, 61–62
 straight, 58–59
Hands, 72–89, 111, 122
 baby, 81–83
 creases in, 78–79, 82
 cupped, 84–86
 graceful, 87–89
 grasping, 77–80
 mapping, 77, 81, 84, 87
 photographing, 25, 73
 proportions of, 75
 sketching, 76
Highlights, 17, 35, 42, 49

Lighting, 19, 24, 75, 114
Likeness, capturing a, 34, 47–48, 60

Mapping, 108, 114, 120
 See also Faces, mapping; Hands, mapping
Materials, 11–21
 See also Pastel; Surfaces

Pastel, 14, 17–18
 brands, 14, 17, 48
 cleaning, 58
 colors, 12, 17
 layering, 12–13, 17, 48, 66, 100

red, 99
 soft versus hard, 14, 17–18, 48–49
 soft versus oil, 18
Pastel pencils, 17
Photos, 21, 23–27
 choosing, 21–26, 75, 114
 combining, 26–27, 120
 editing, 119
 hand, 25, 73
 lighting in, 23–24, 26
 narrative, 24
 taking, 21, 24
Poses, 23–24, 30, 53, 60–63, 75

Rule of thirds. *See* Golden mean

Safety, 19
Scumbling, 62
Shadows, 21, 24, 41–42
Shapes, 60, 75
Sketching, 16, 19, 26, 75–76, 107–108, 120
Skin tone, 21, 43–45, 114
 dark, 45, 60–63
 light, 44, 68–71
 medium, 64–67
 warm, 43
Strokes, 61
Subjects, 21, 26–27, 47
Surfaces, 12–16
 colored, 12–16
 toning, 12–13, 16, 19
 tooth, 12–15
Surfaces, brands of
 Ampersand Pastelbord, 12–13
 Art Spectrum Colourfix Super-tooth Board, 13–14
 Saint-Armand Sabretooth Pastel Paper, 13–14
 Townsend Pastel Paper, 12, 15
 UART Sanded Pastel Paper, 12–13
 Wallis Sanded Pastel Paper, 13, 15, 74
Texture, 12–15, 74

Value, 18, 27, 48, 53, 60, 74, 85, 109

Washes, 14–16

The best in fine art instruction and inspiration is from *North Light Books*!

Whatever age or skill level, even if you think that you can't be taught, you'll learn how to draw incredibly realistic children in basic black and white with time-tested drawing principles refined into a foolproof program by authors Carrie Stuart Parks and Rick Parks.

ISBN-13: 978-1-58180-963-3
ISBN-10: 1-58180-963-8
PAPERBACK, 128 PAGES, #Z0687

Drawing people is more than just accurately capturing the anatomy and details of the subject. Artists who capture the soul of the model breathe life into the artwork by expressing a mood, idea or emotion that cannot be captured by accurate rendering alone. *Life Drawing* will give you all the tools necessary to draw people accurately and expressively, setting it apart from books that teach technique only. A variety of materials (NuPastel, charcoal and graphite) will be used to give the intermediate artist a range of options to choose what works best for the subject of each drawing.

ISBN-13: 978-1-58180-979-4
ISBN-10: 1-58180-979-4
HARDCOVER, 160 PAGES, #Z0813

The approach to color theory in *Confident Color* makes selecting colors easy and efficient. You will learn the importance of color schemes and contrasts and how to use them effectively when painting to take your compositions to new heights. A lively illustrated color glossary provides a refresher on color basics so that you can focus on more complex theories.

ISBN-13: 978-1-60061-012-7
ISBN-10: 1-60061-012-9
HARDCOVER WITH CONCEALED SPIRAL, 160 PAGES, #Z1059

These books and other fine North Light titles are available at your local fine art retailer or bookstore or from online suppliers. Visit our website at www.artistsnetwork.com.